POP MANGA
DRAGONS AND OTHER
MAGICALLY MYTHICAL
CREATURES

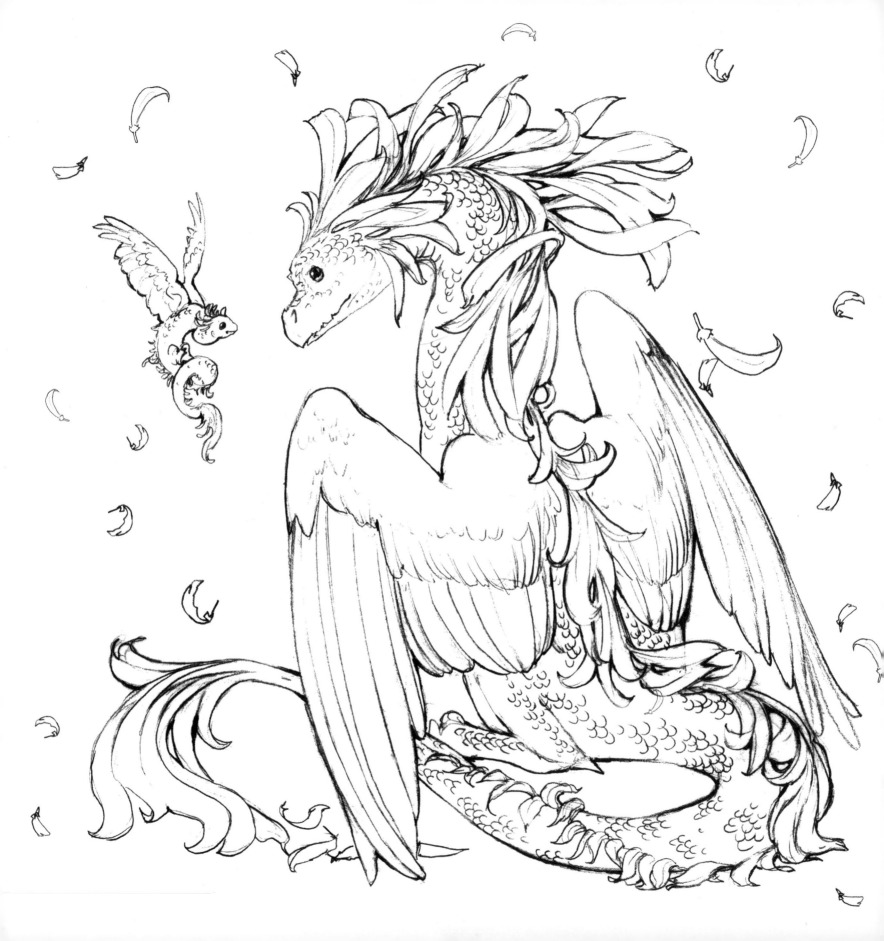

POP MANGA
DRAGONS AND OTHER
MAGICALLY MYTHICAL
CREATURES

A COLORING BOOK

CAMILLA d'ERRICO

WATSON·GUPTILL
CALIFORNIA | NEW YORK

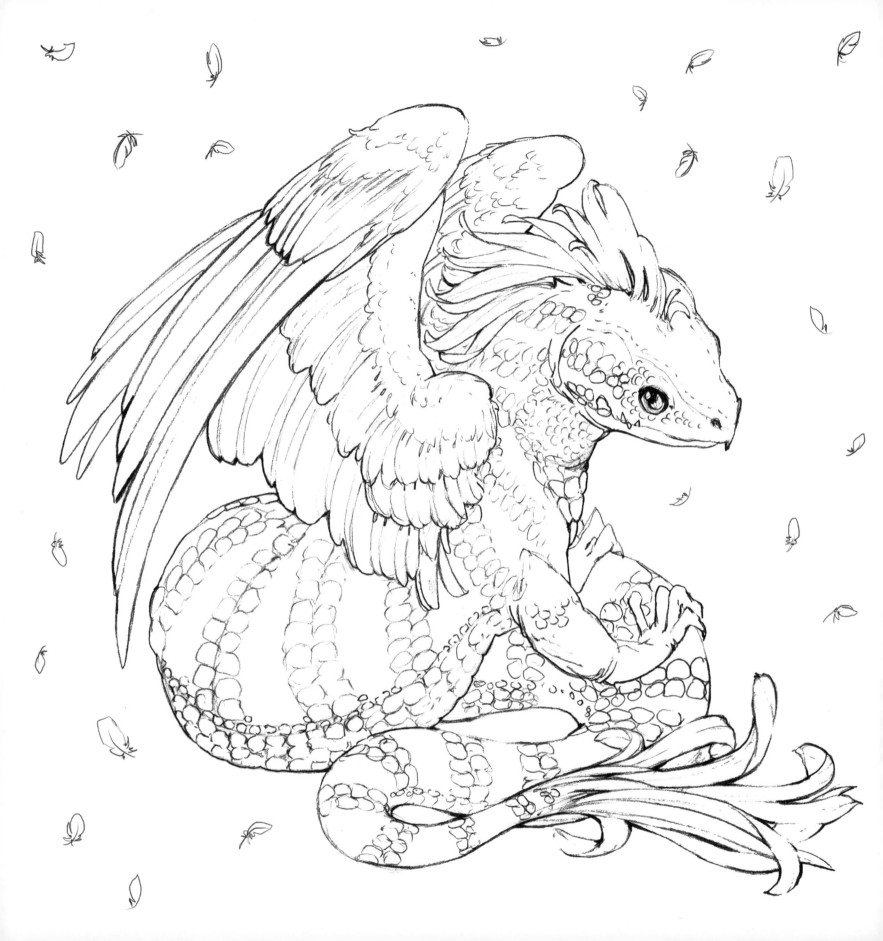

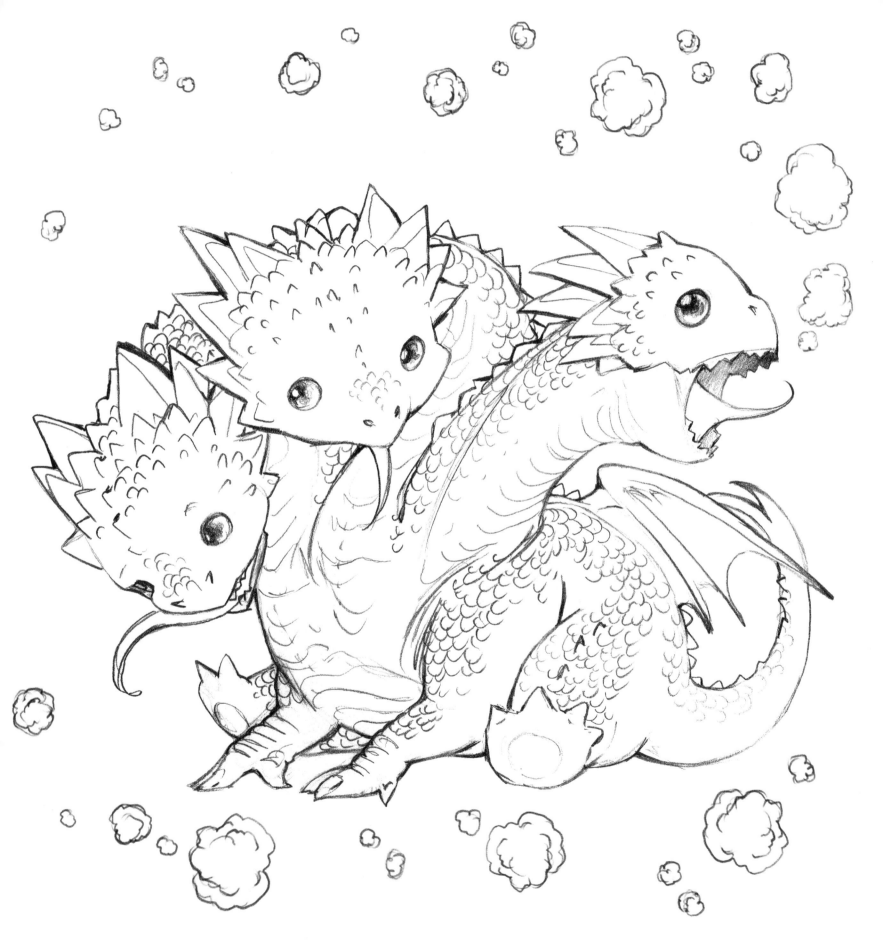

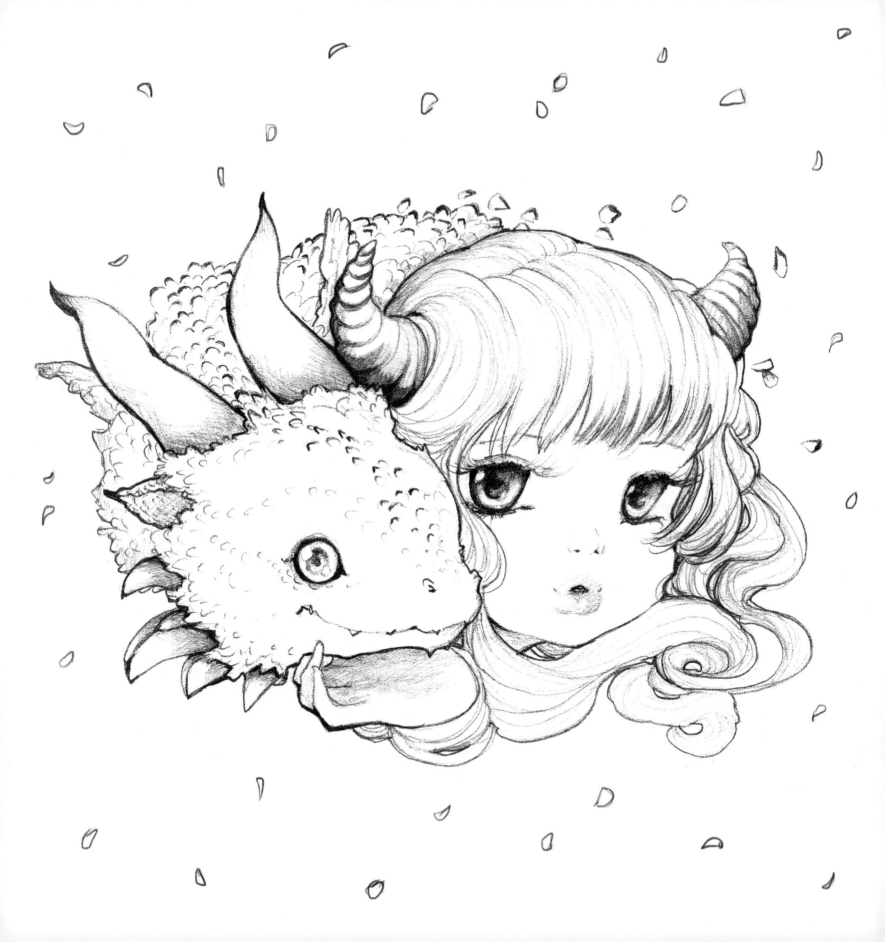

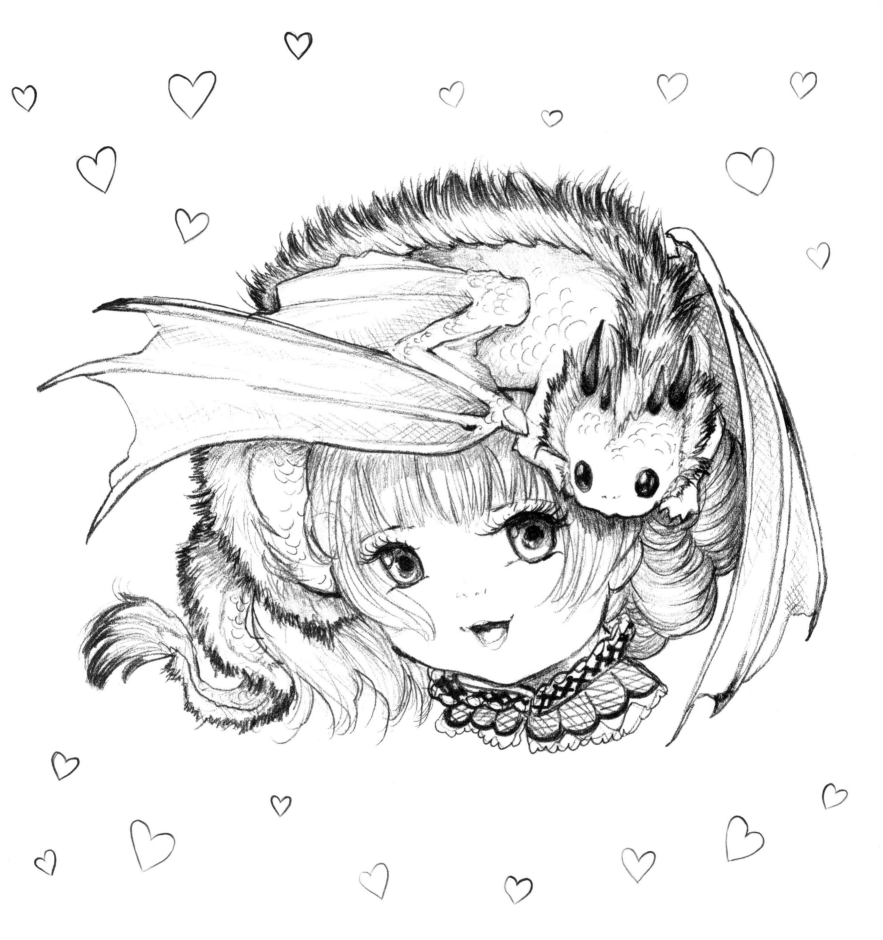

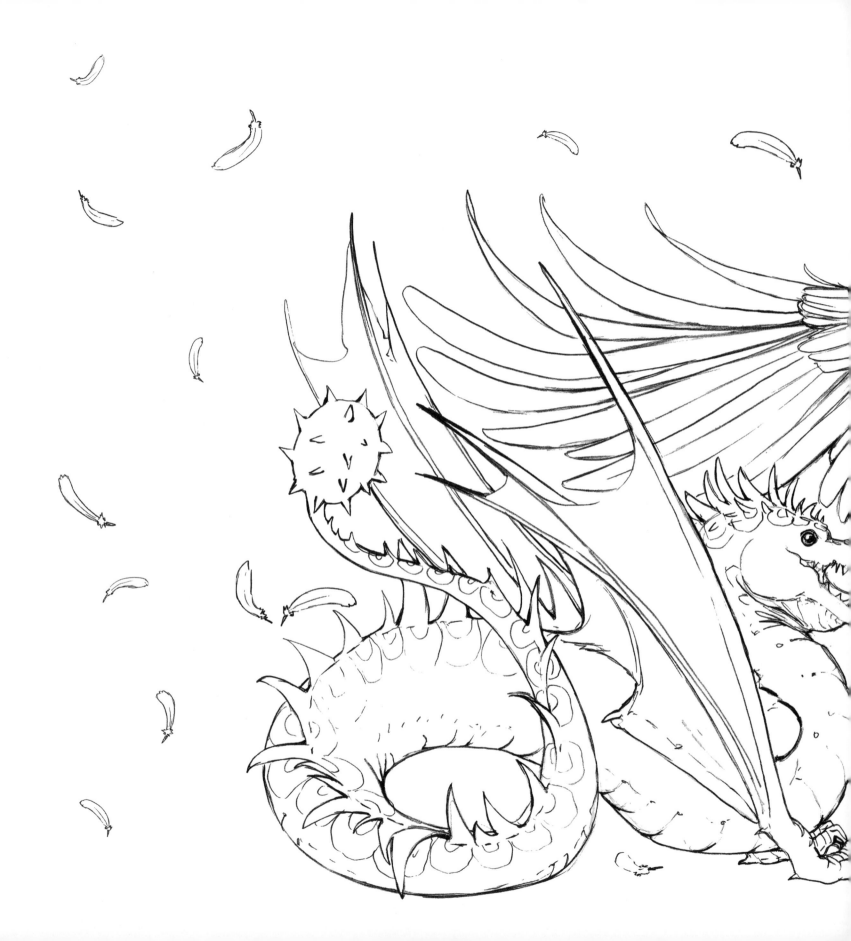

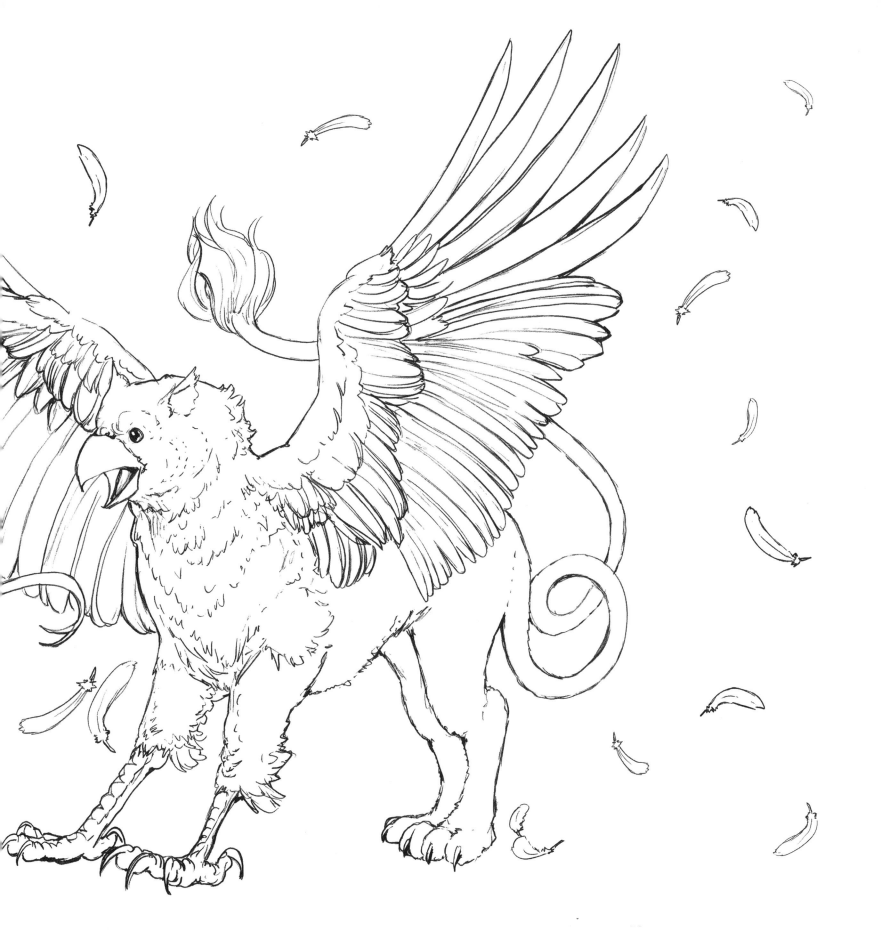

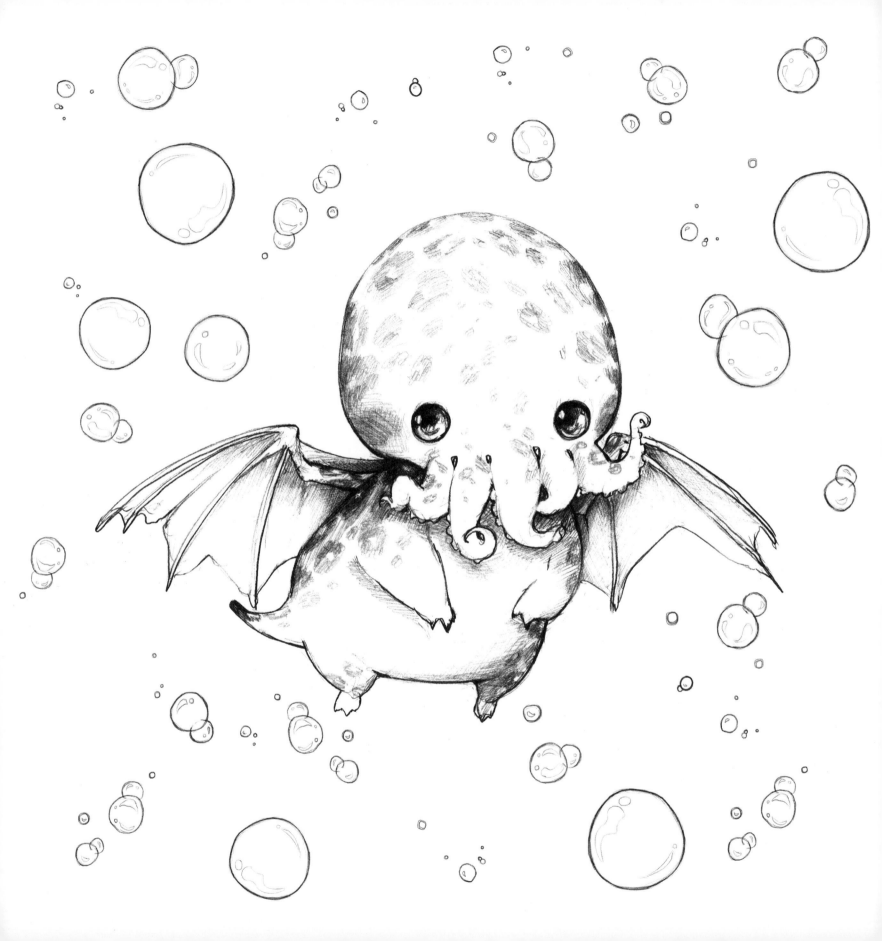

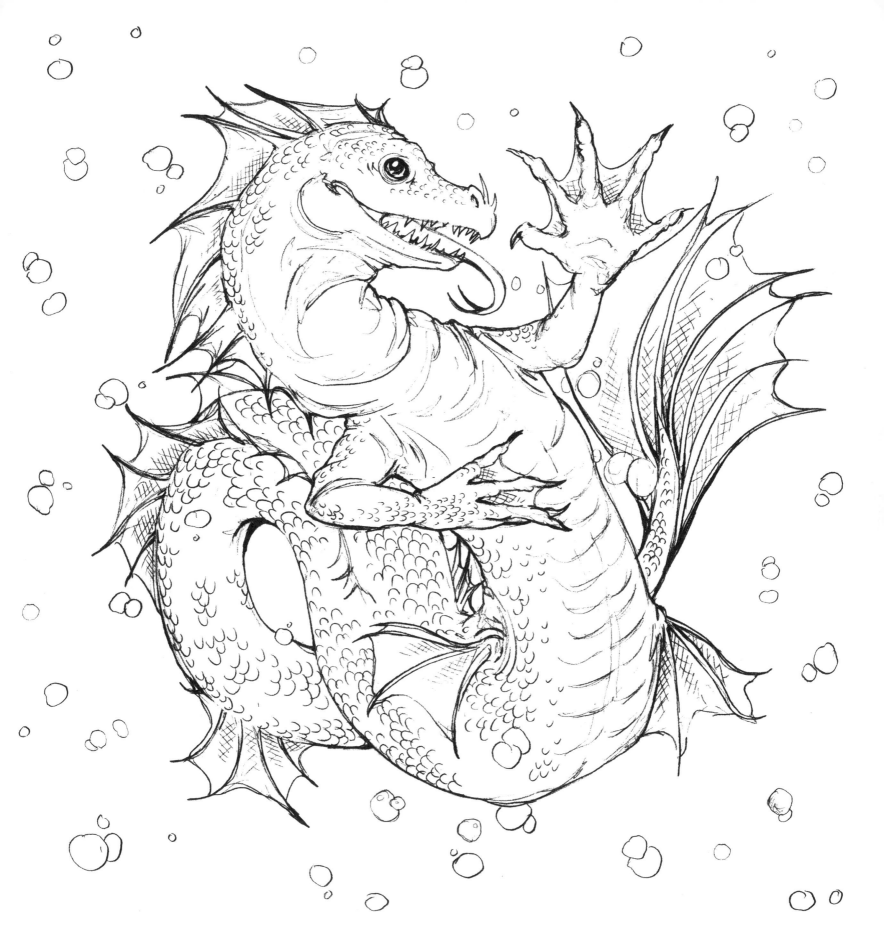

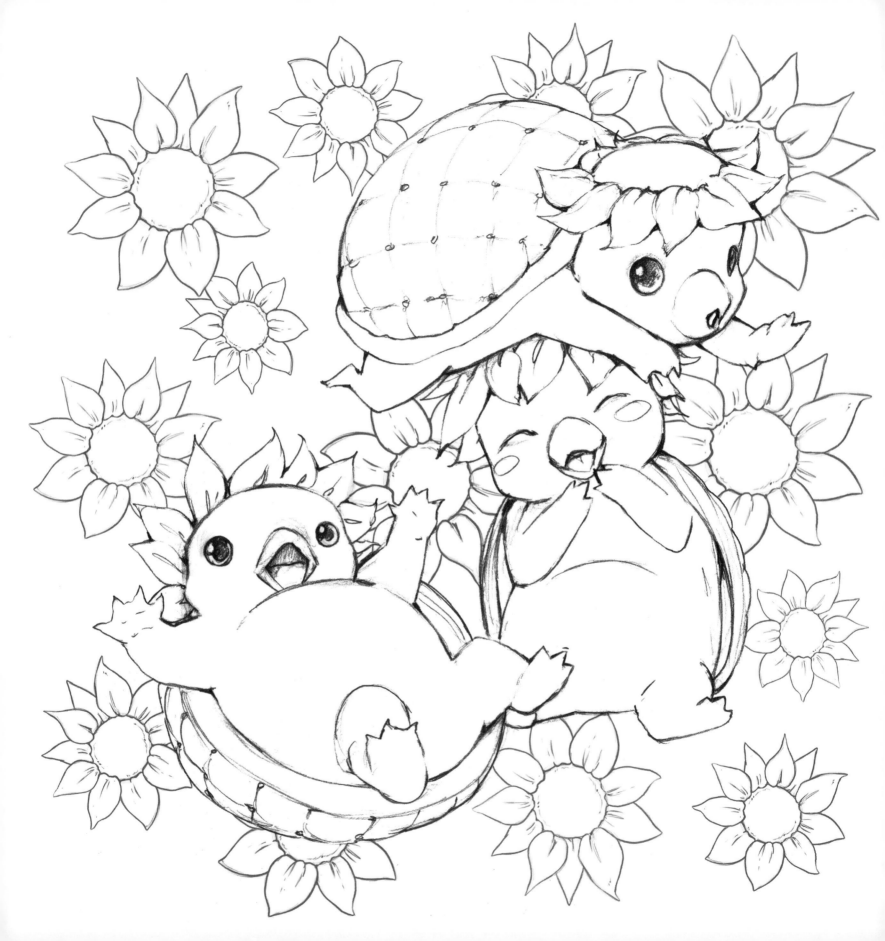

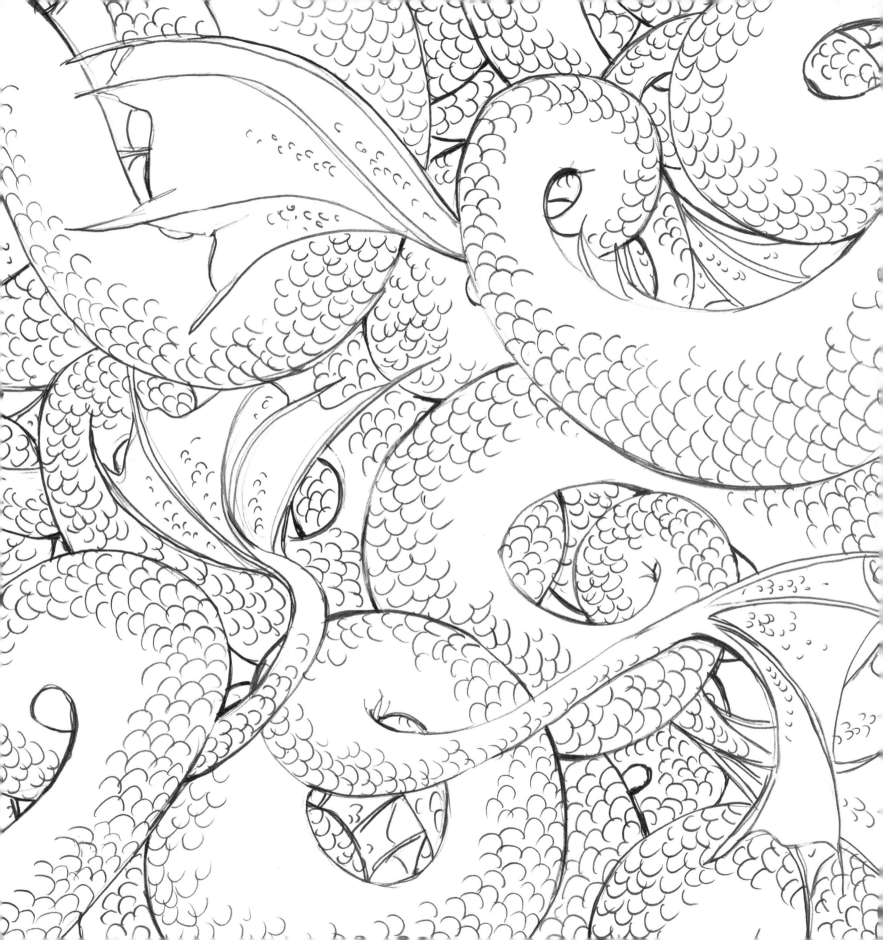

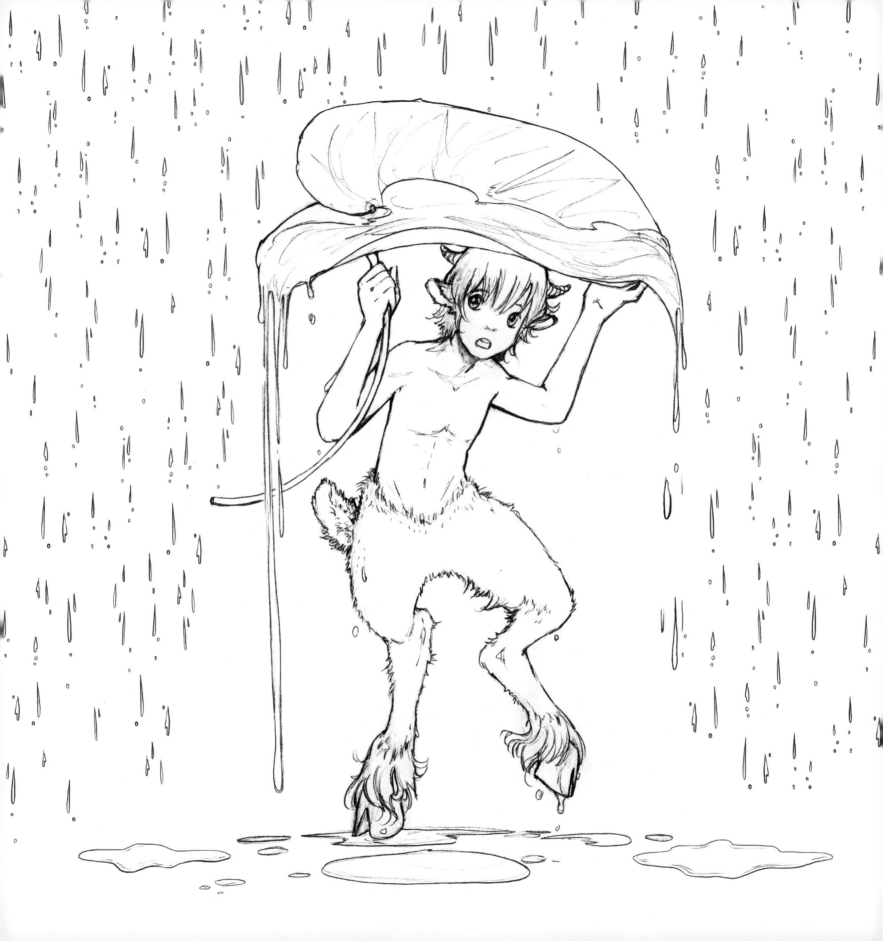

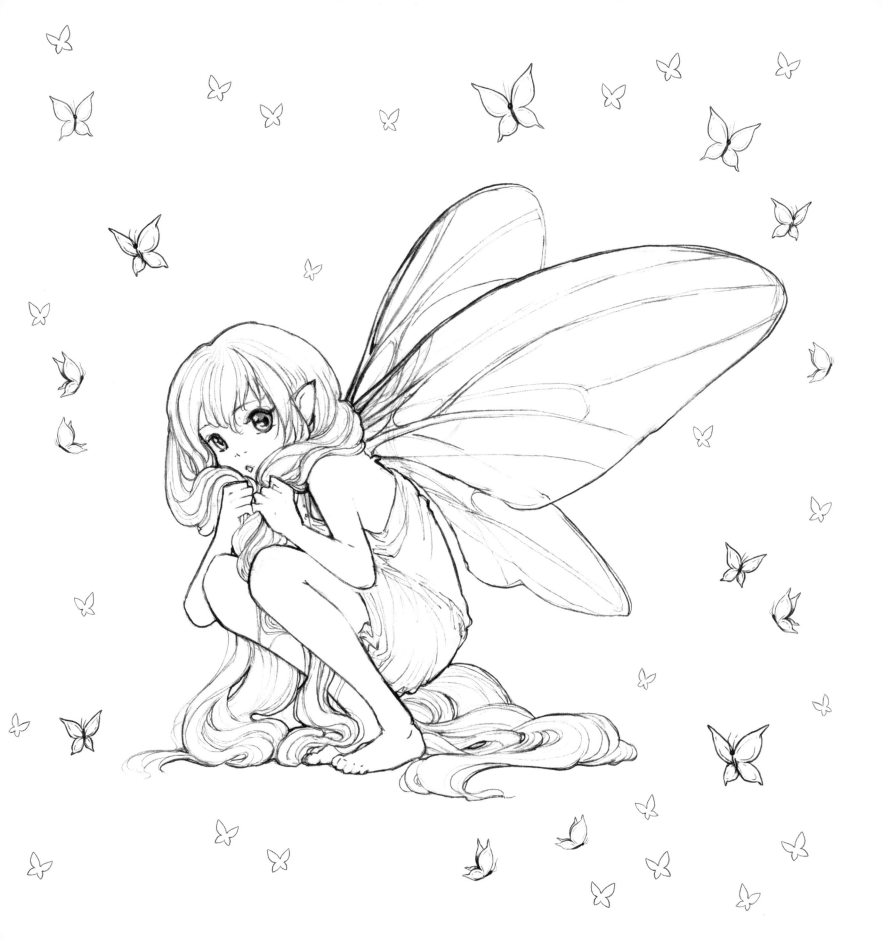

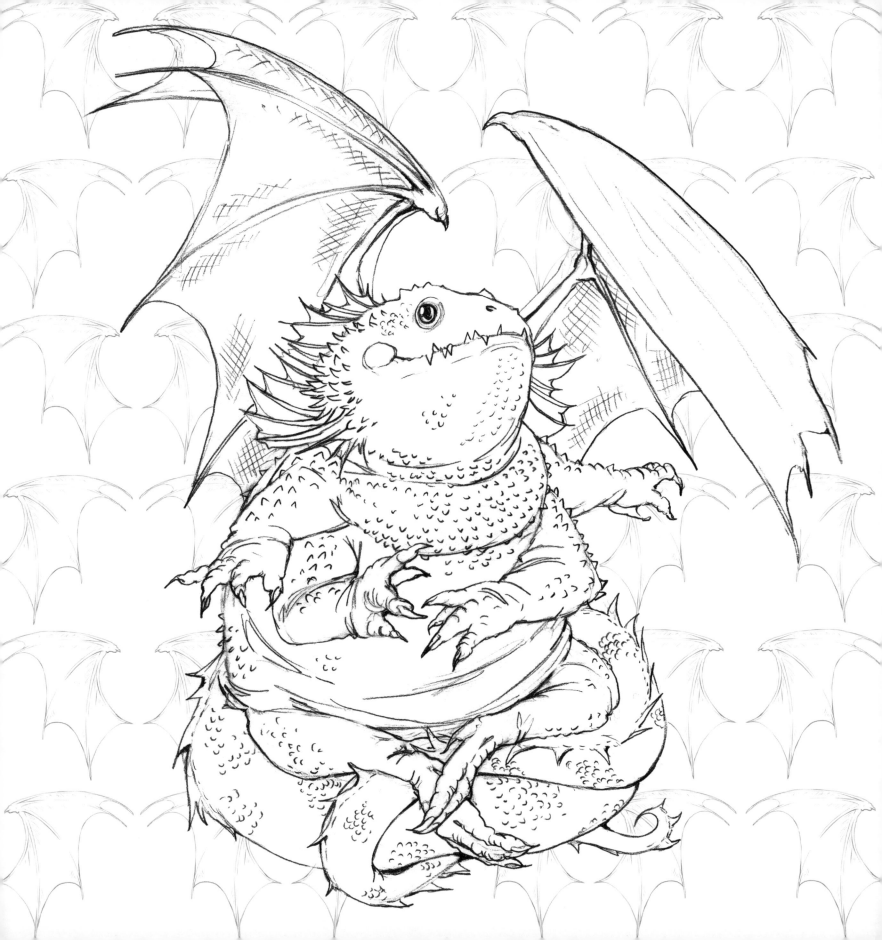

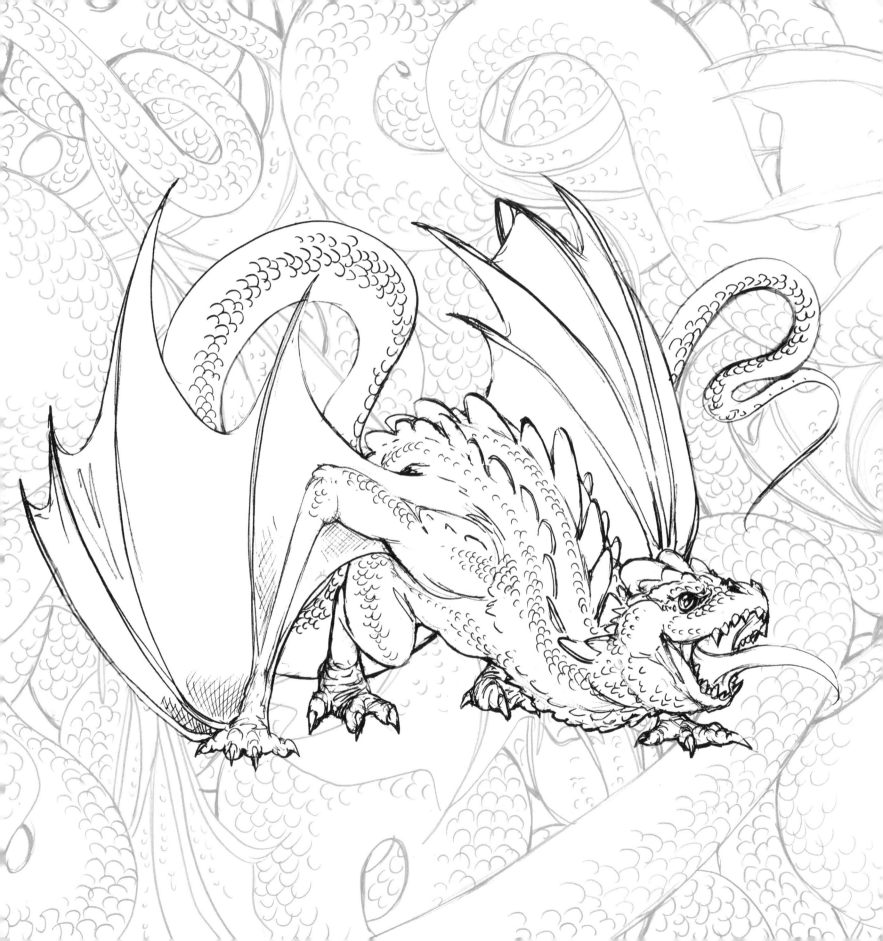

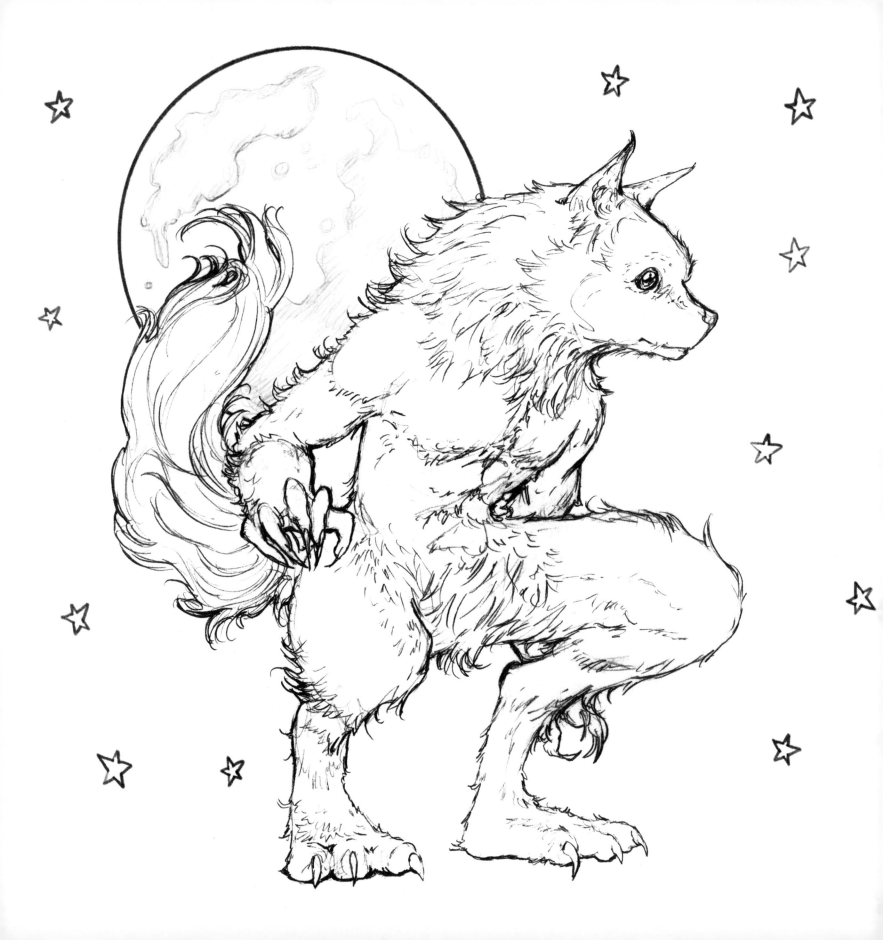

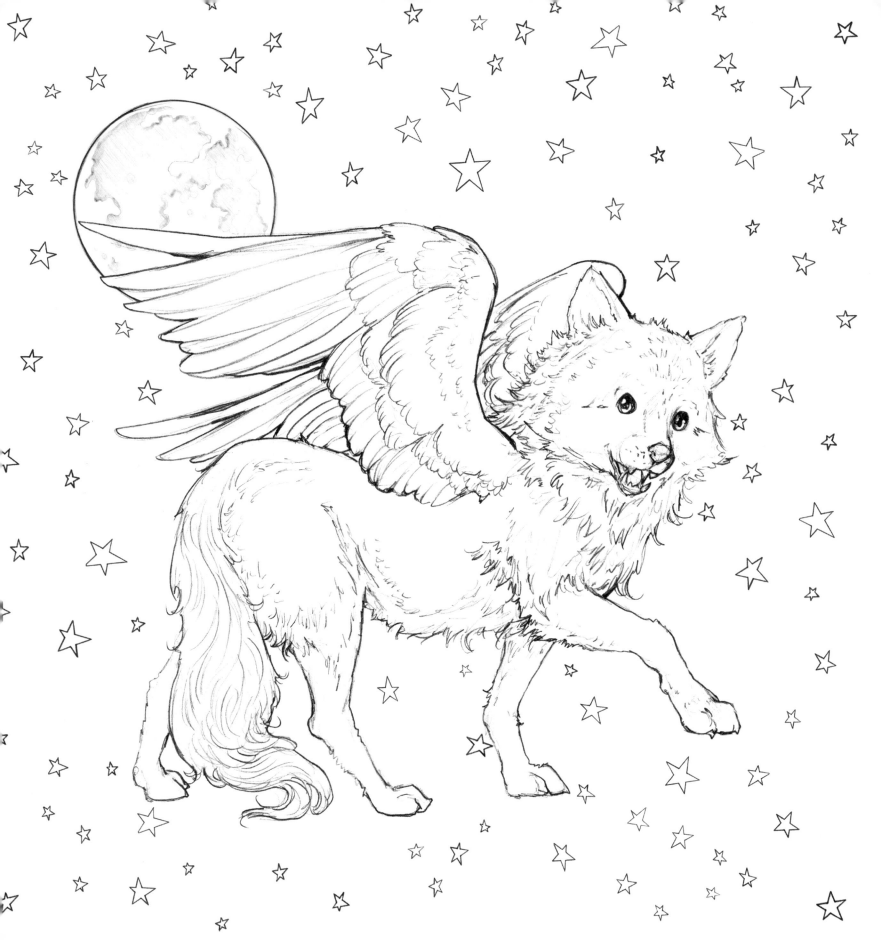

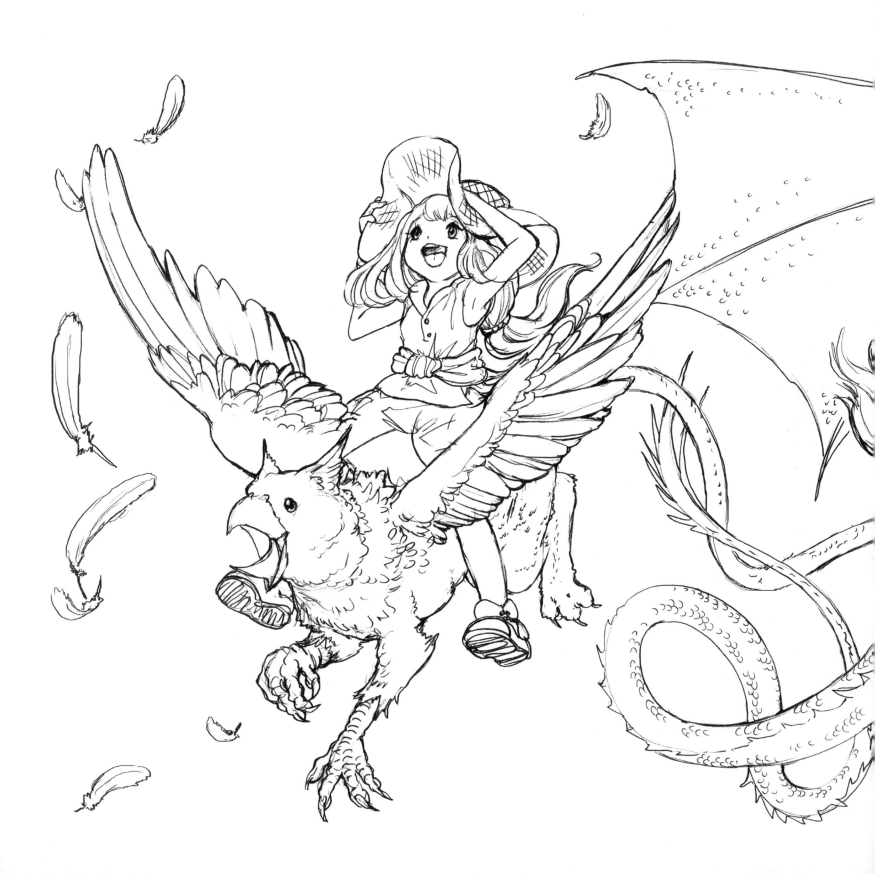

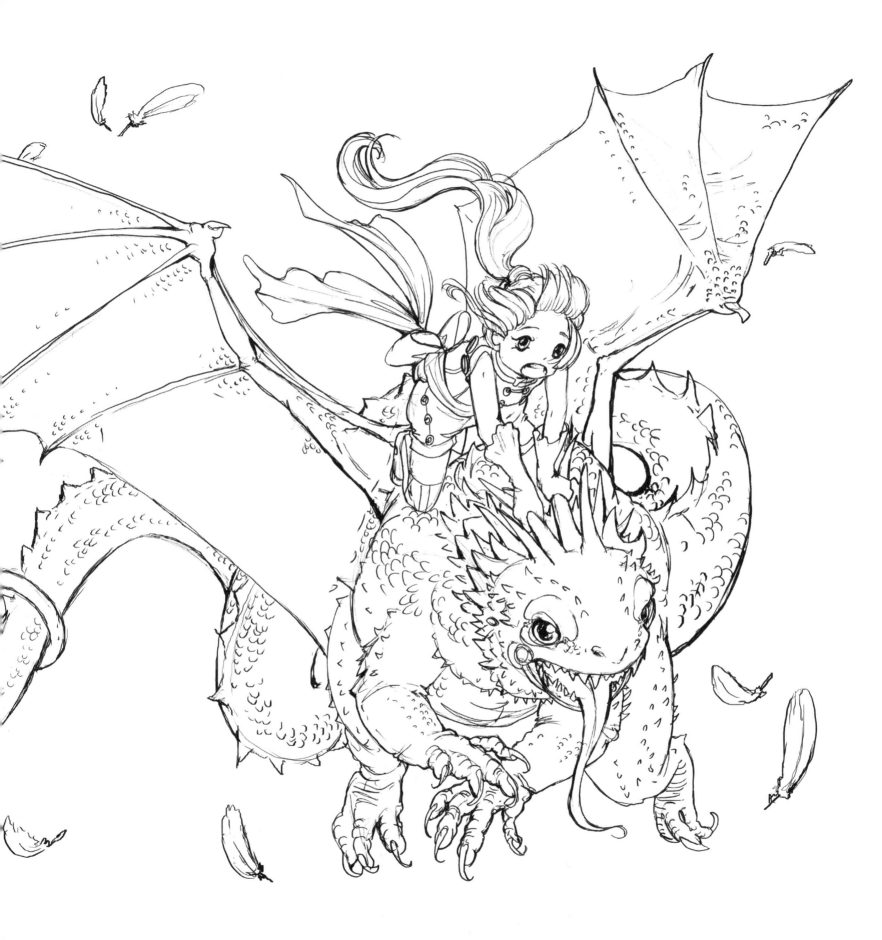

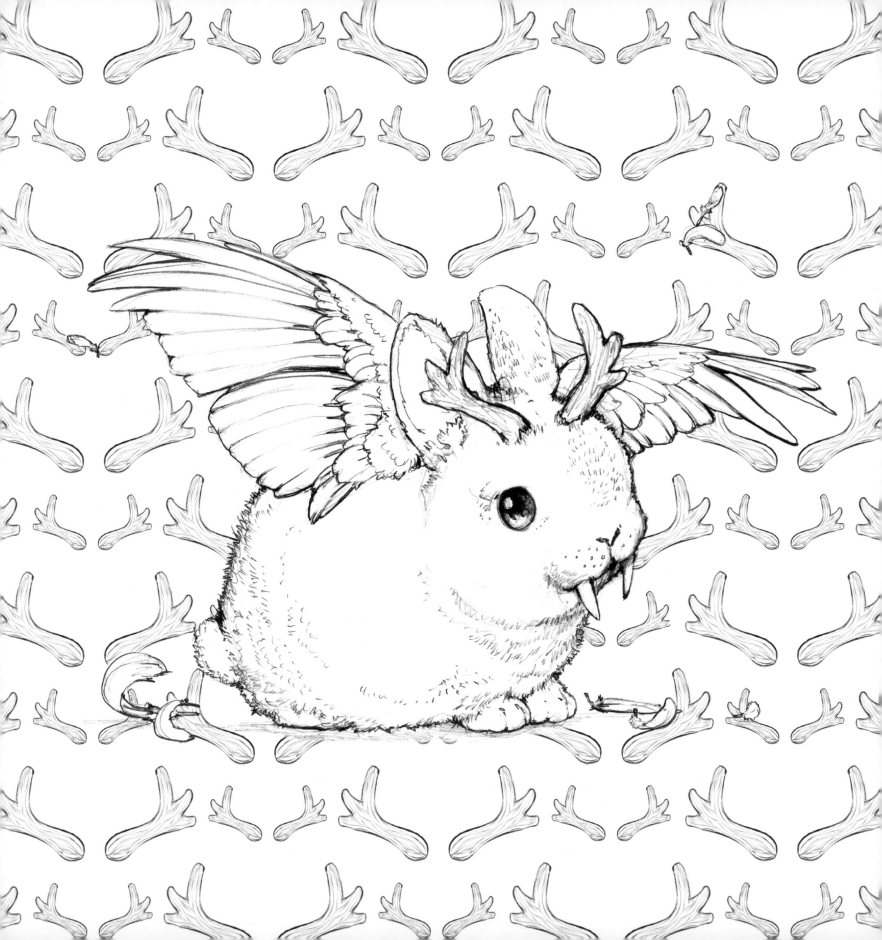

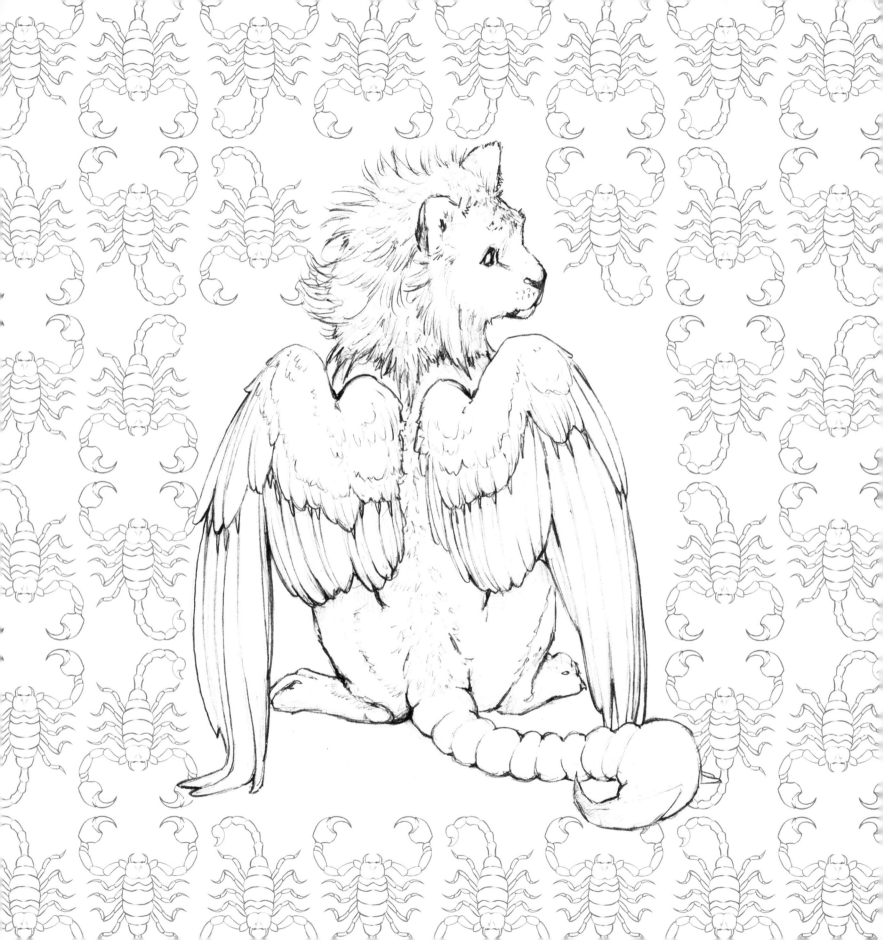

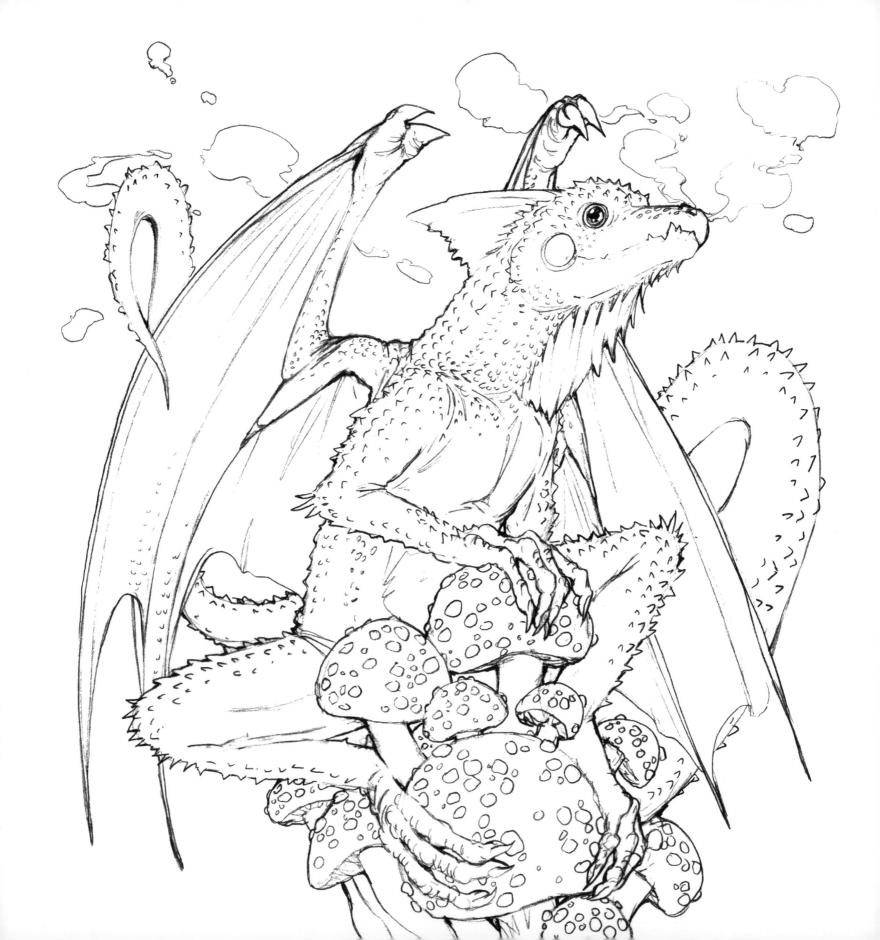

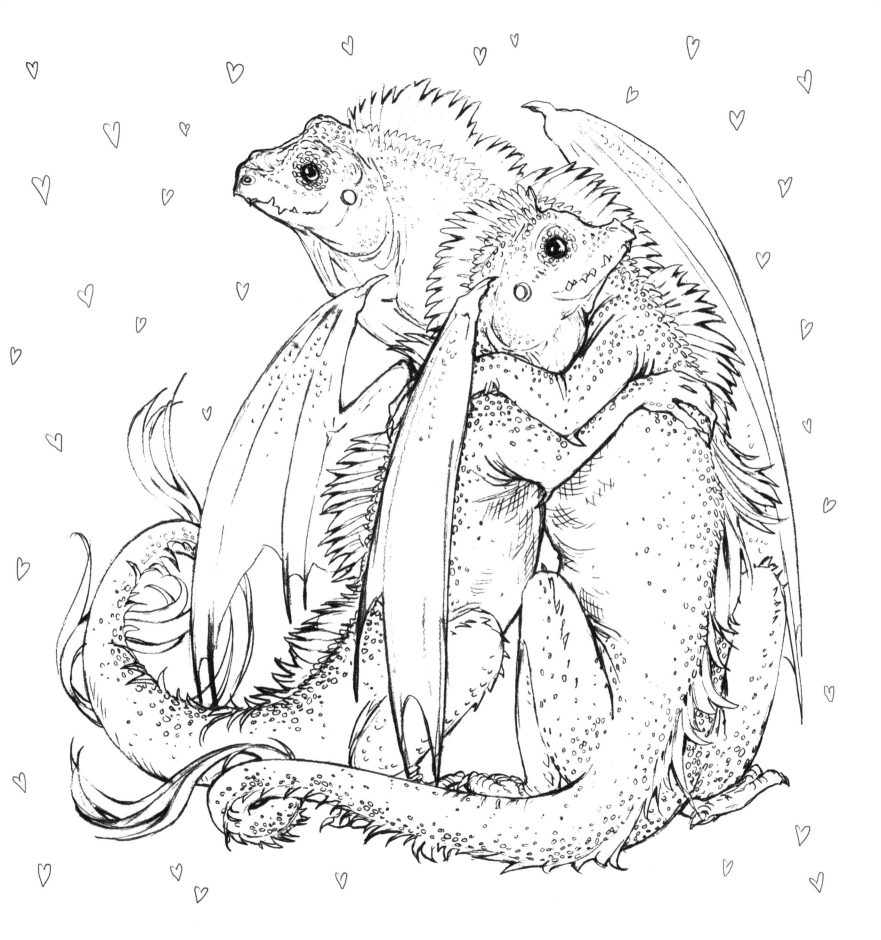

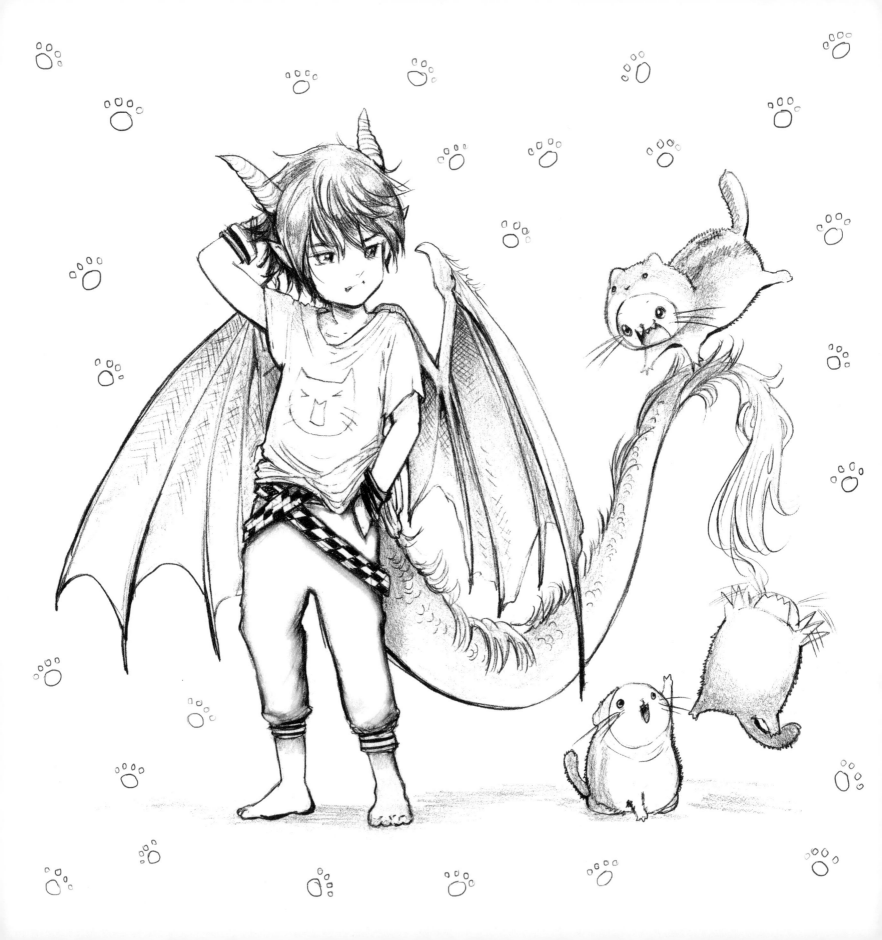

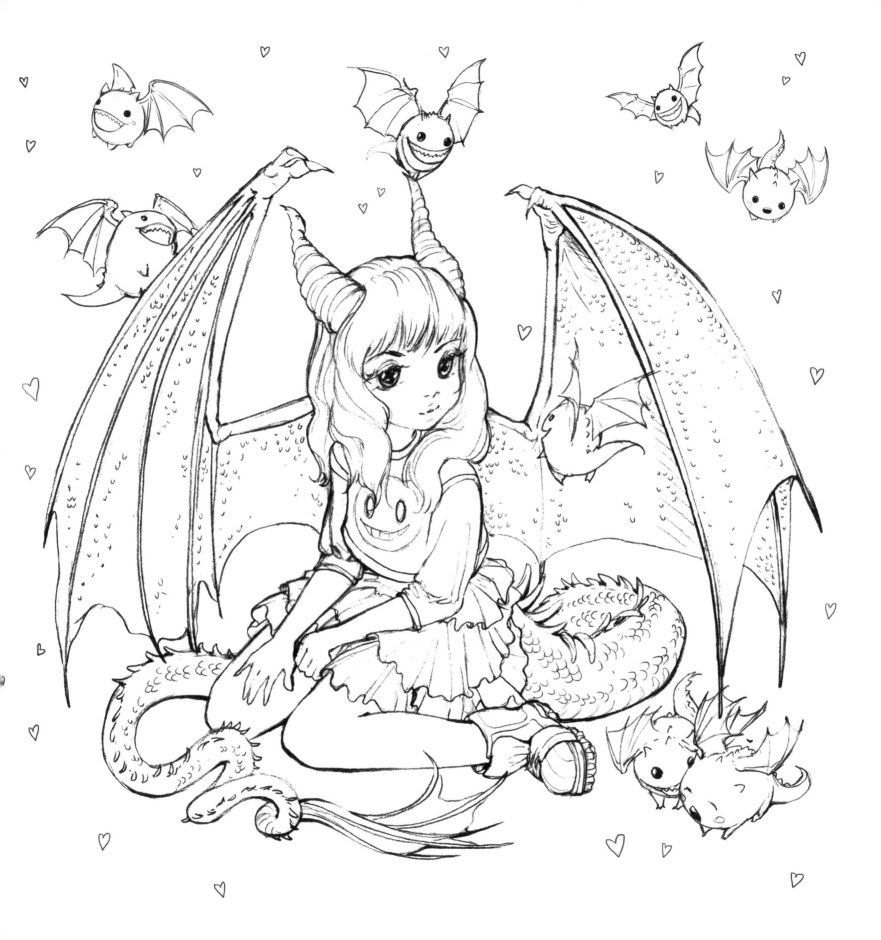

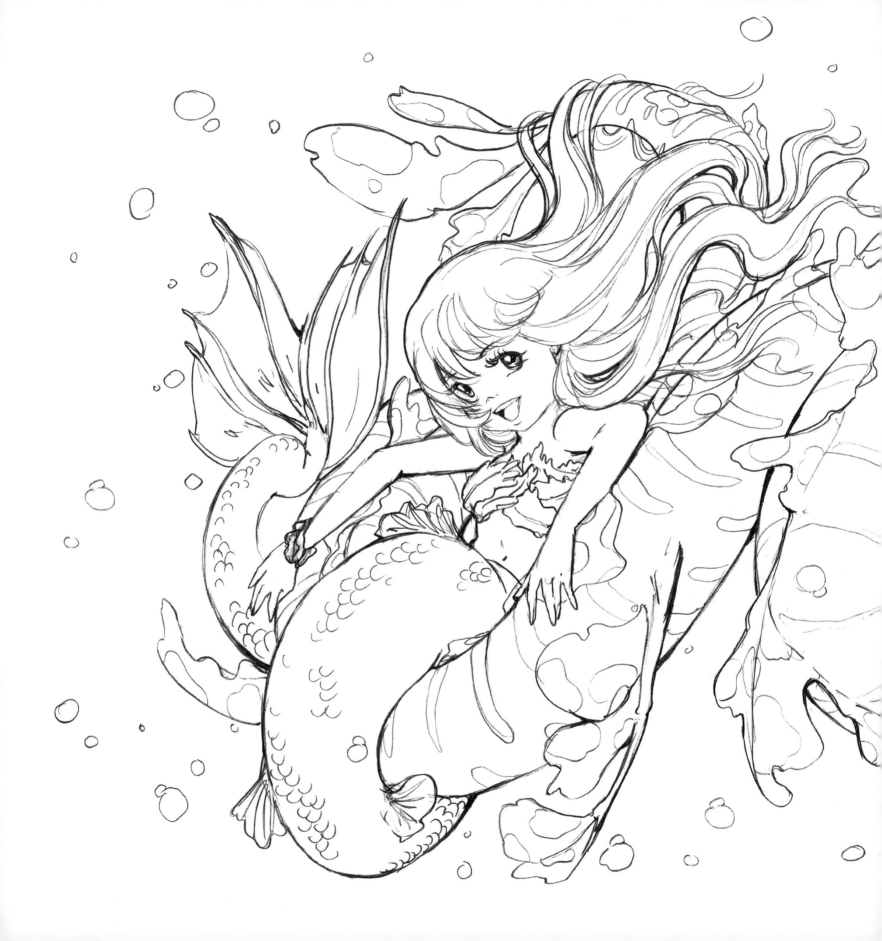

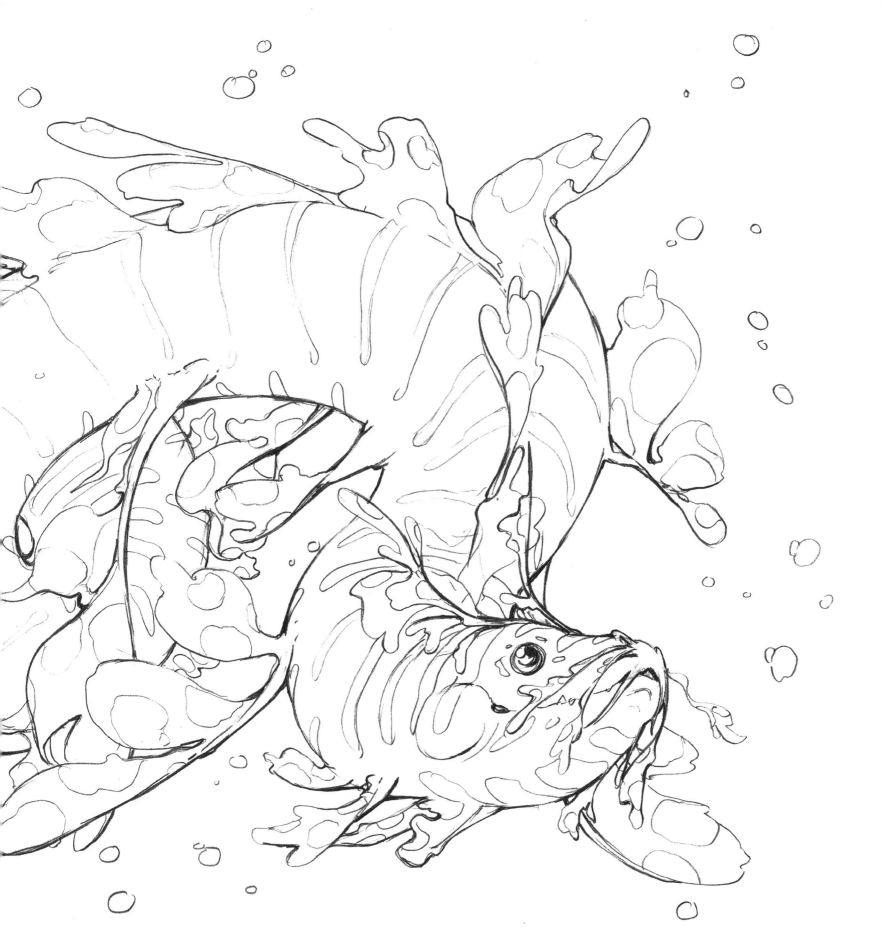

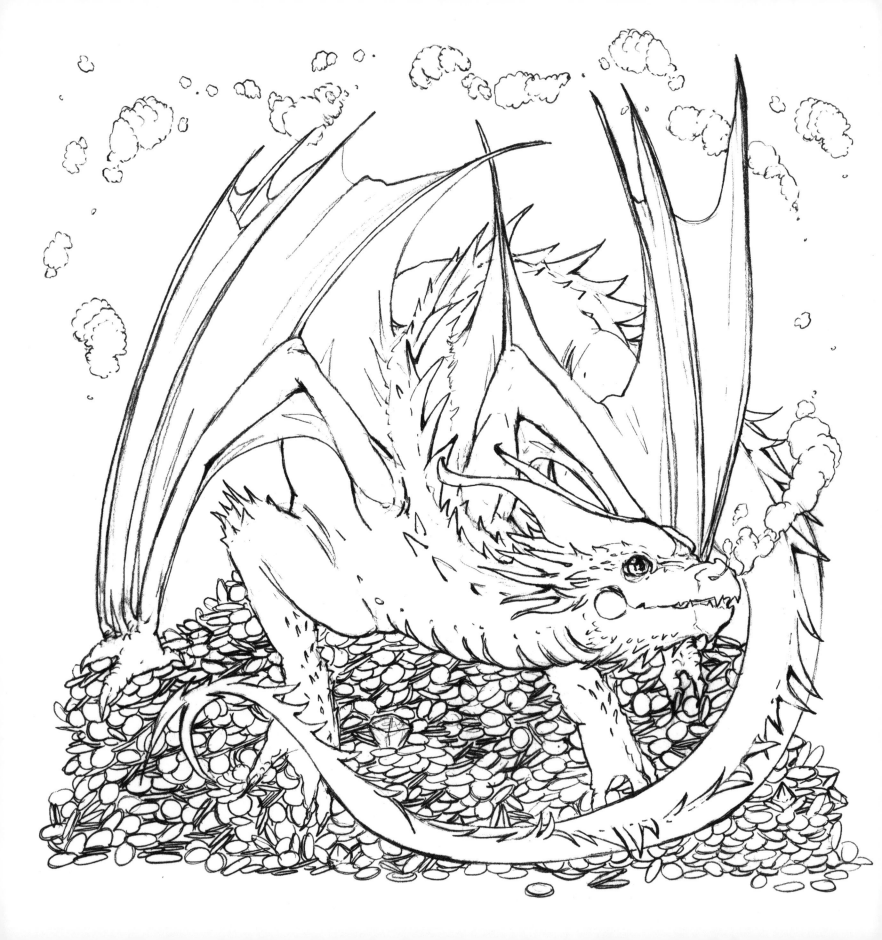

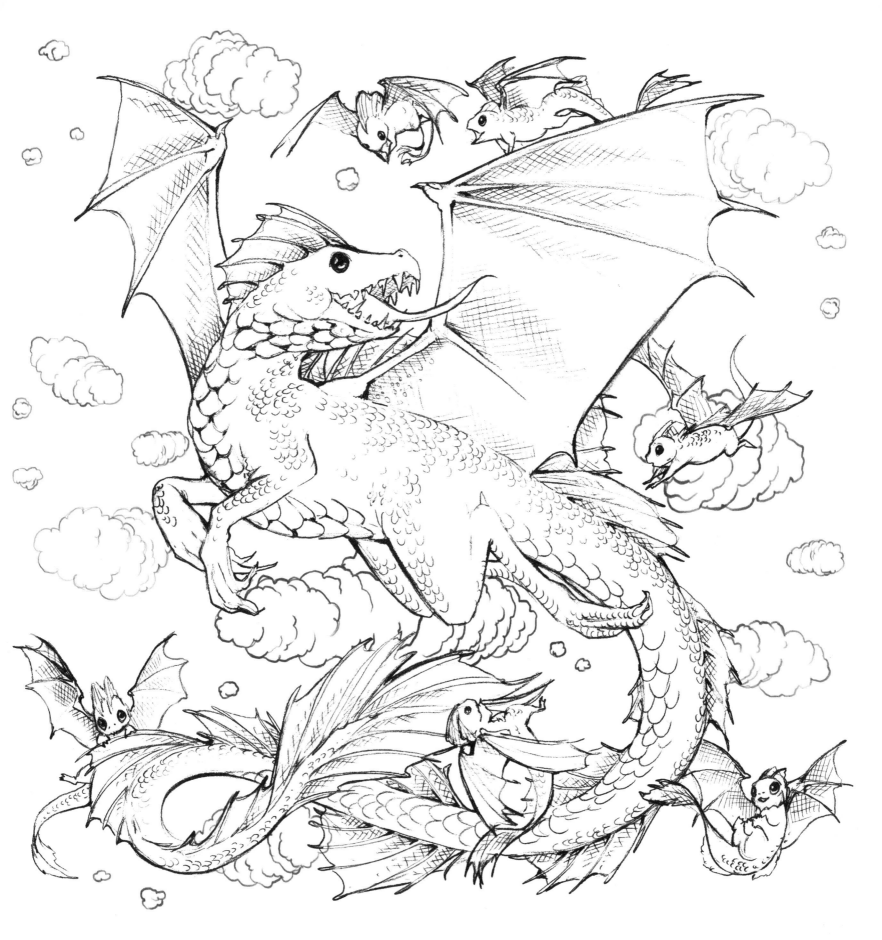

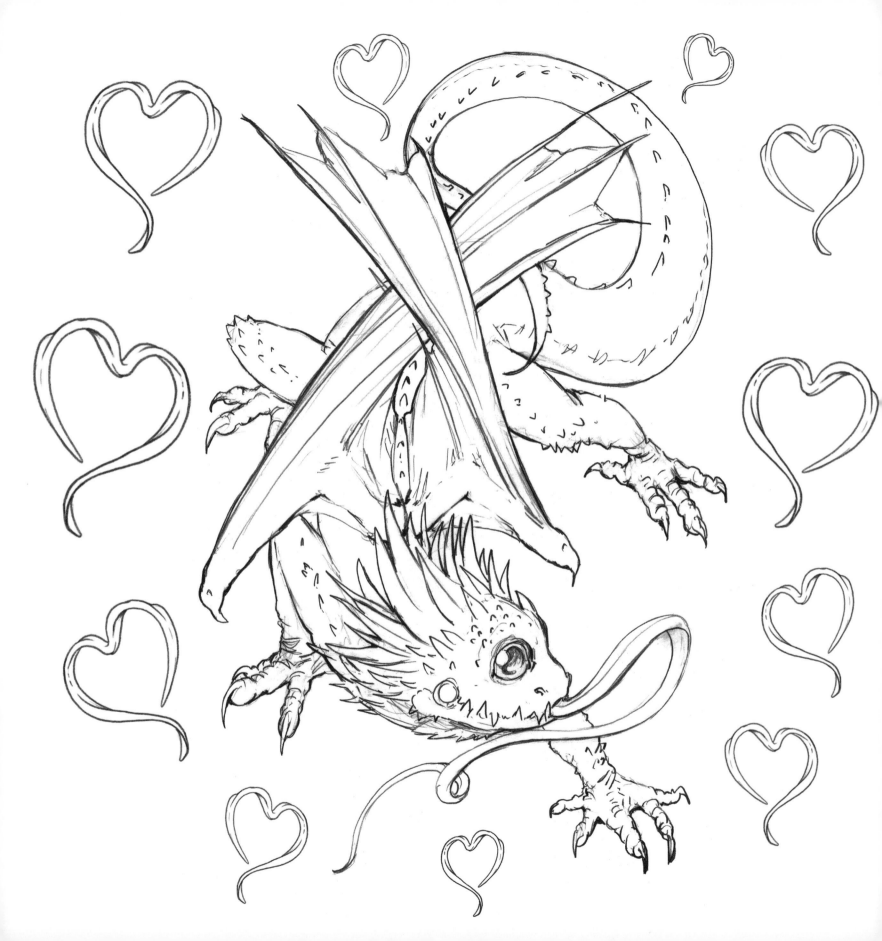

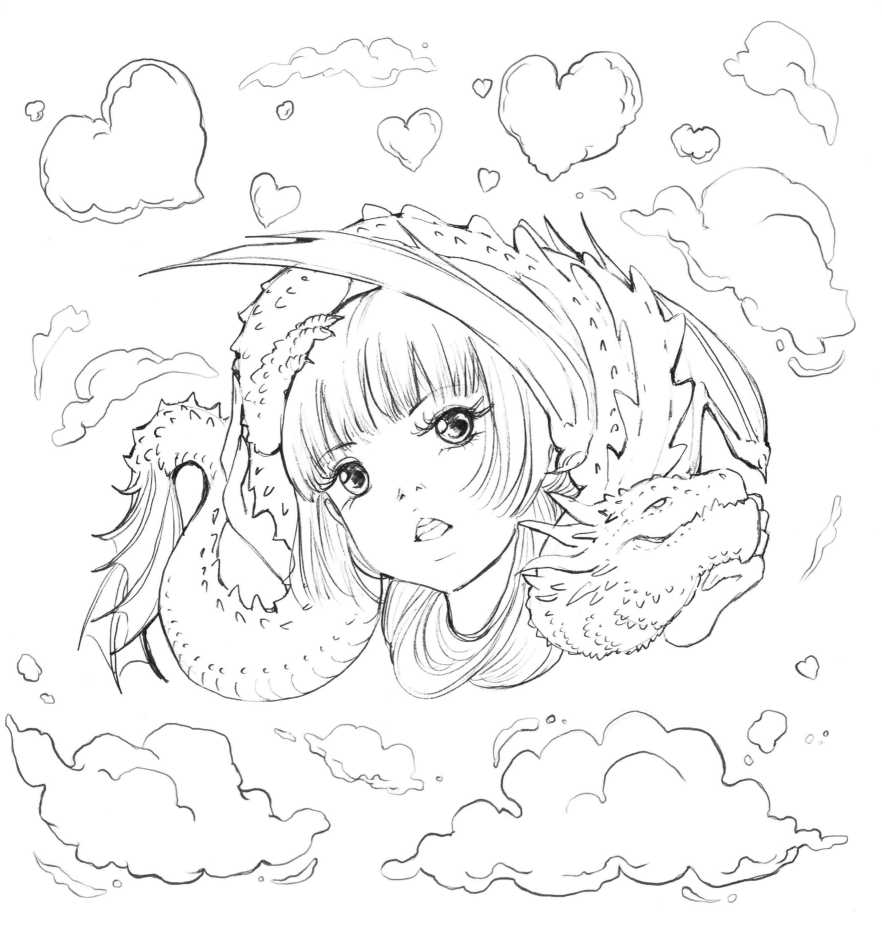

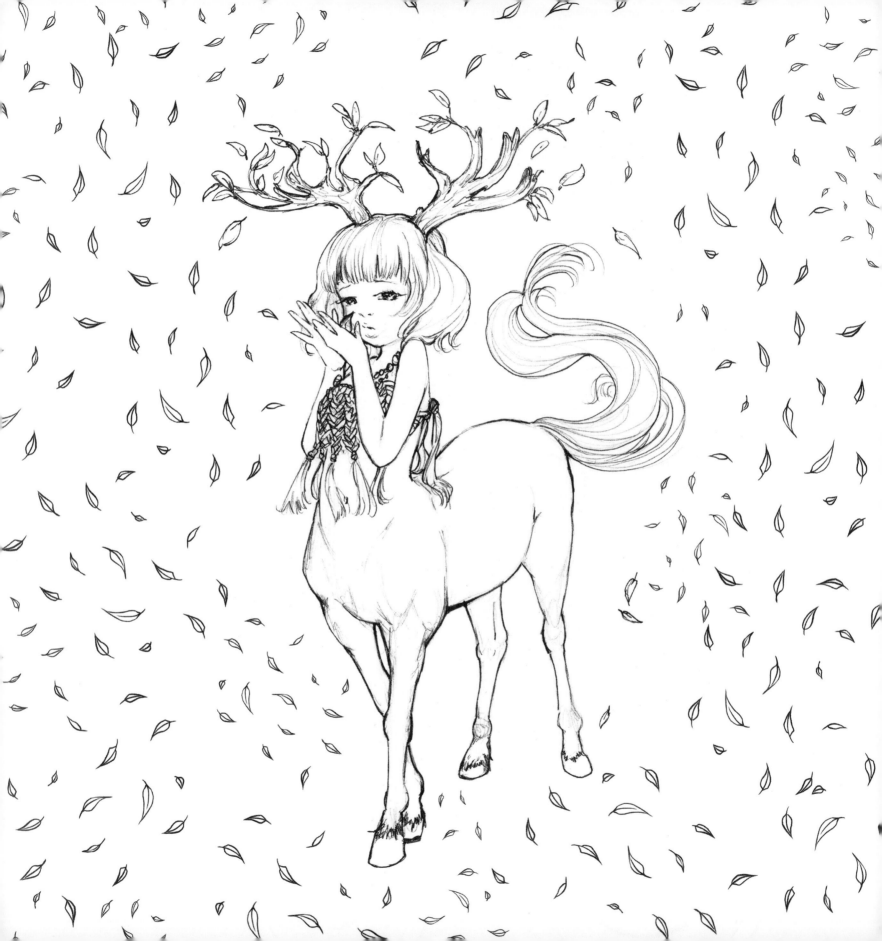

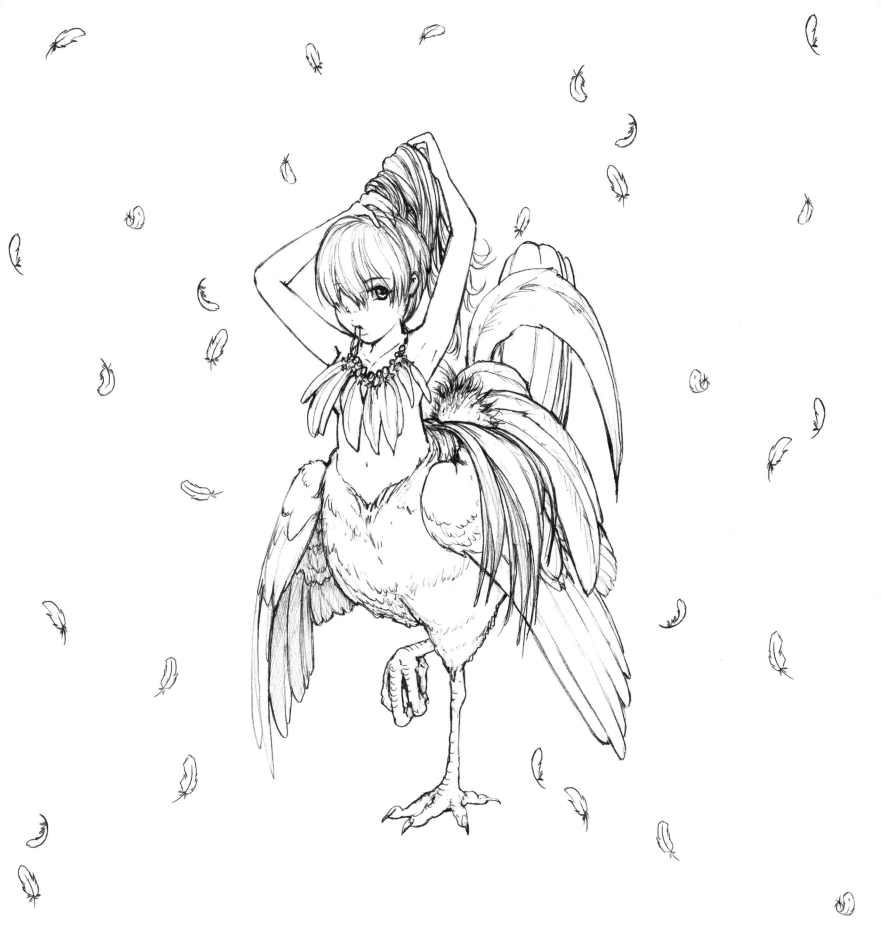

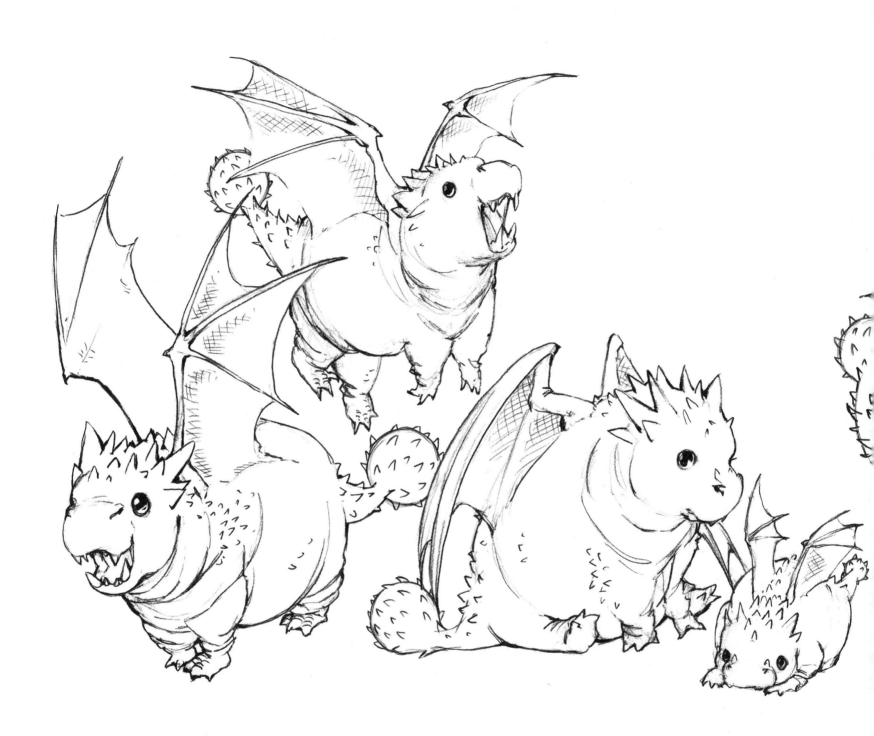

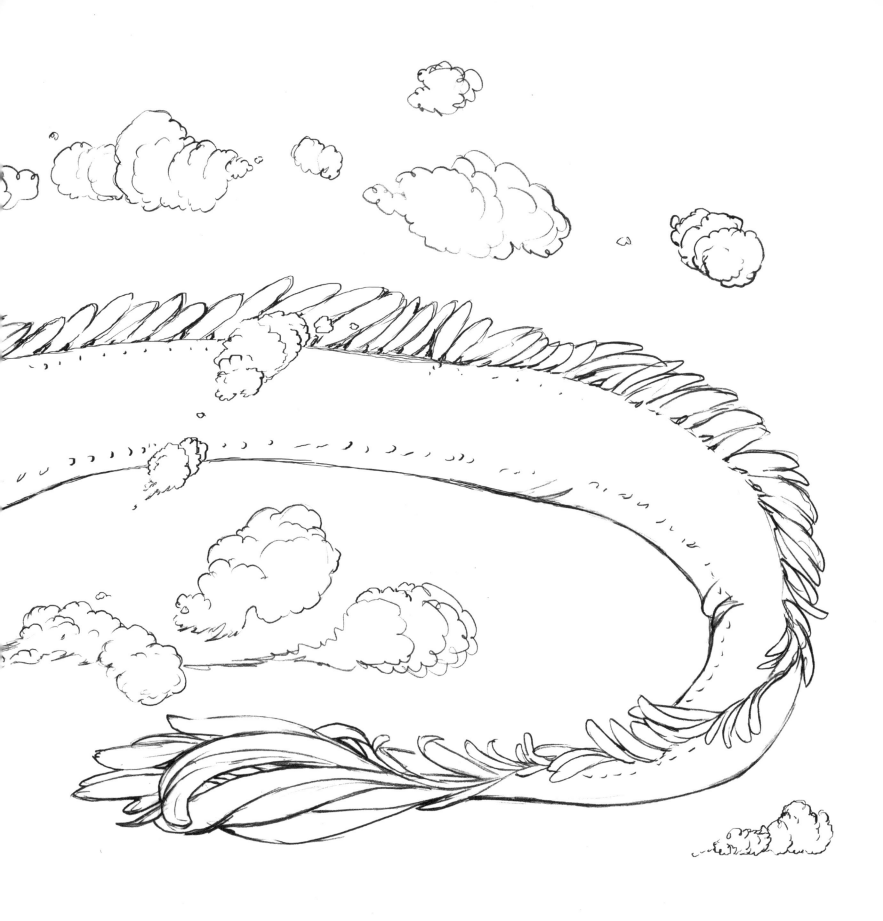

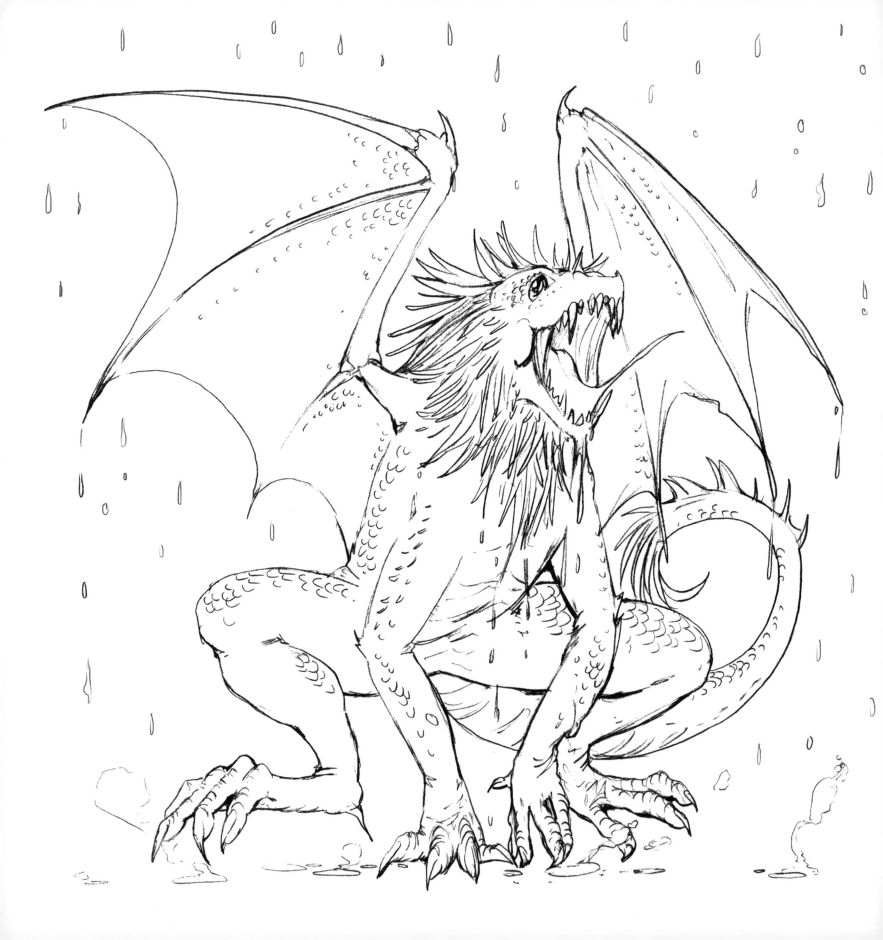

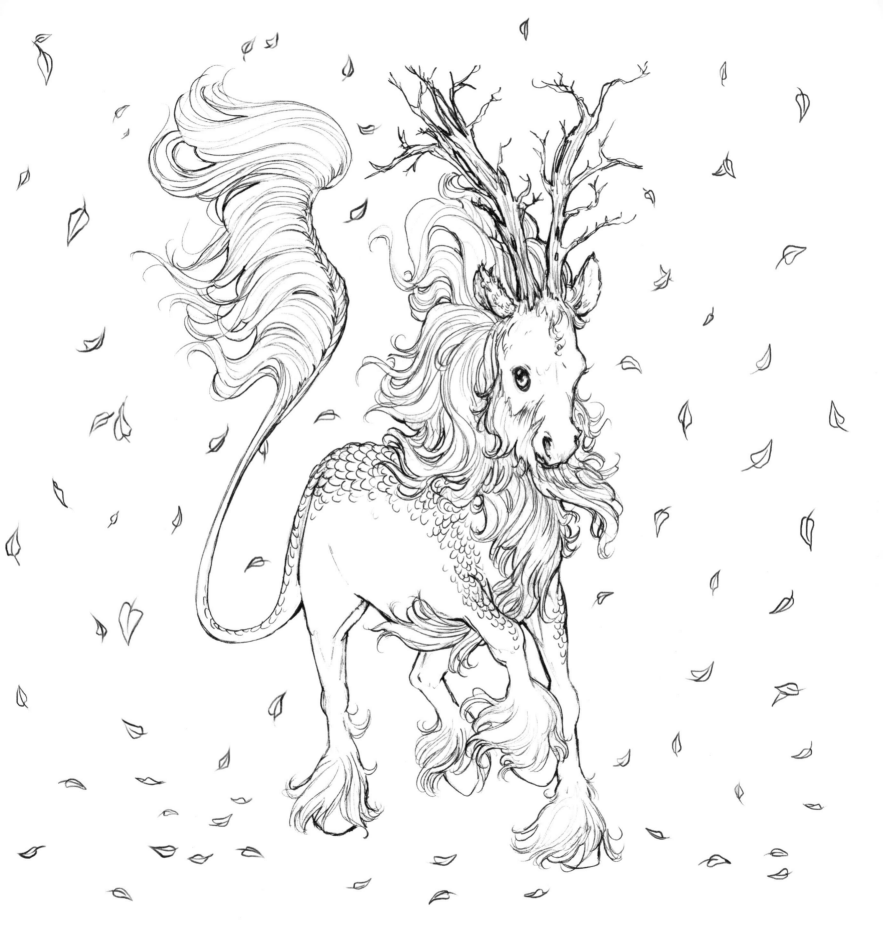

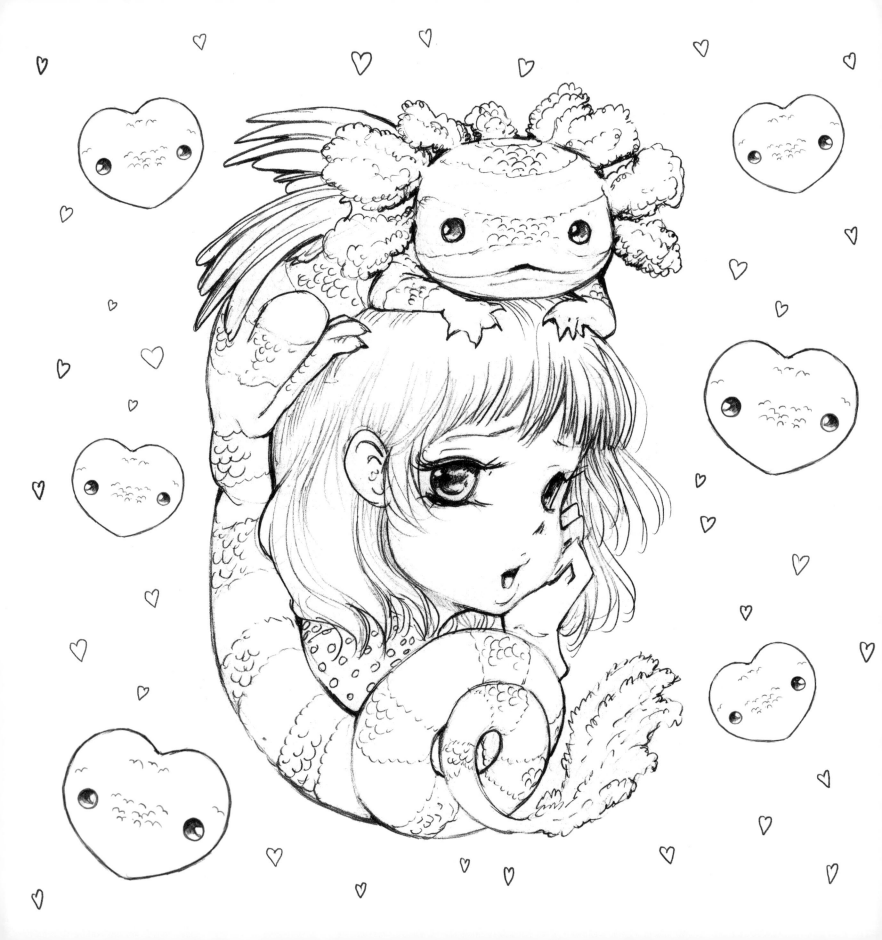

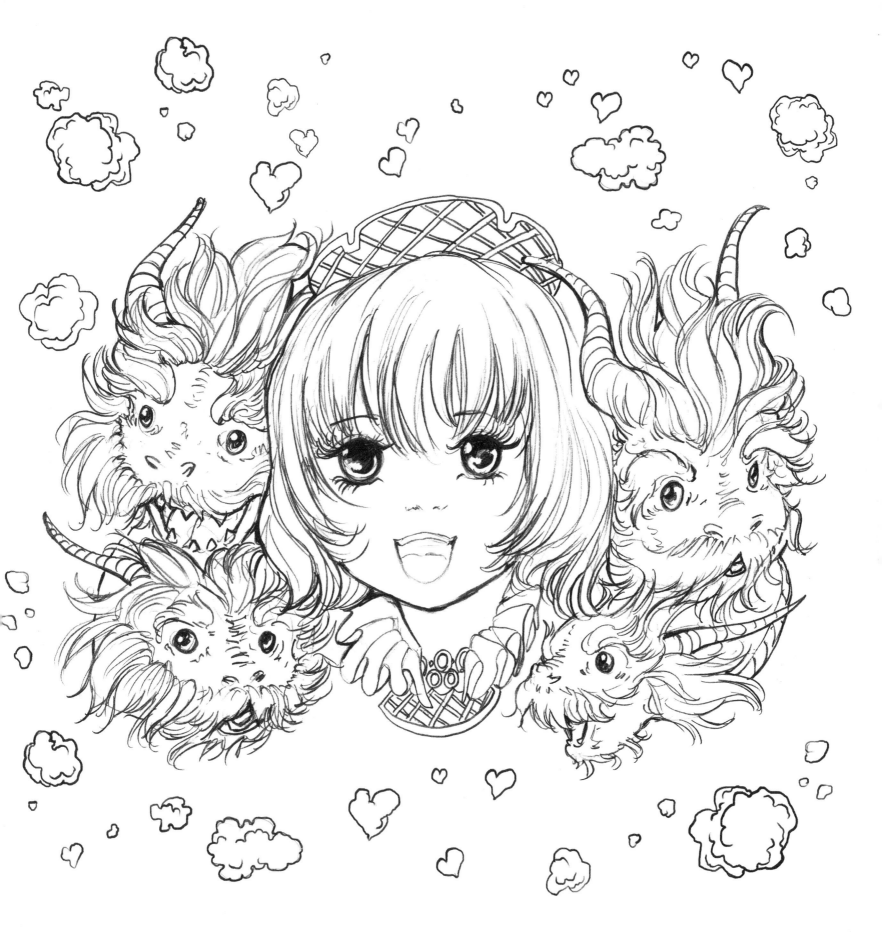

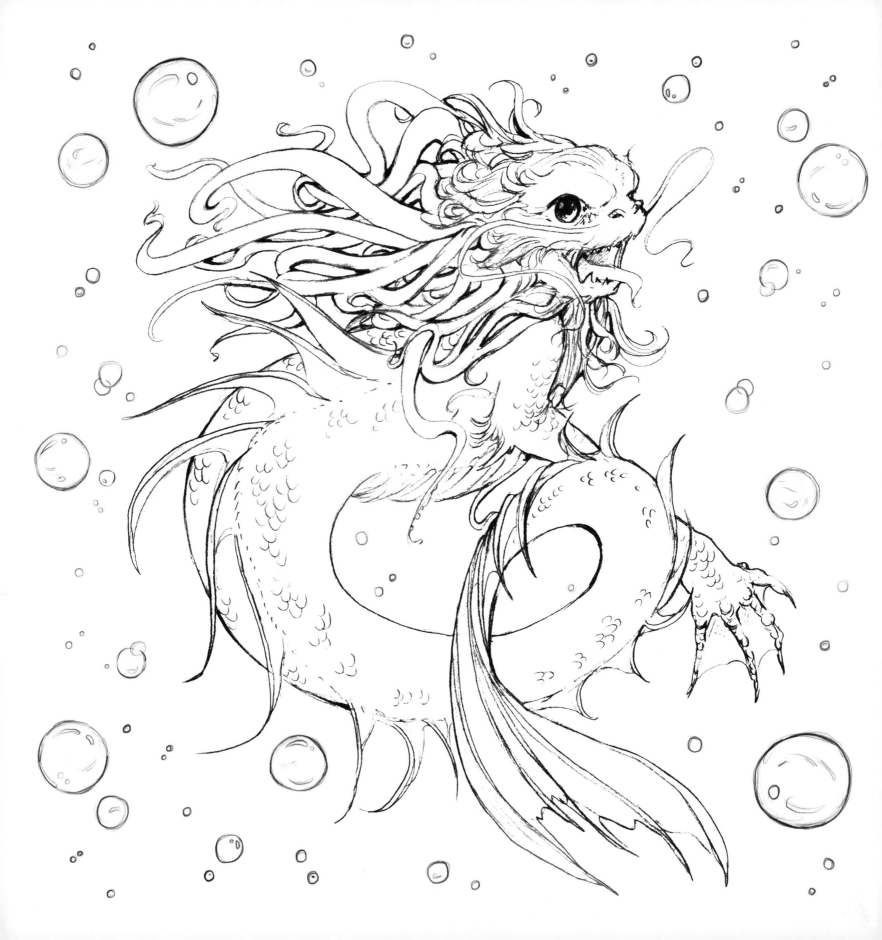

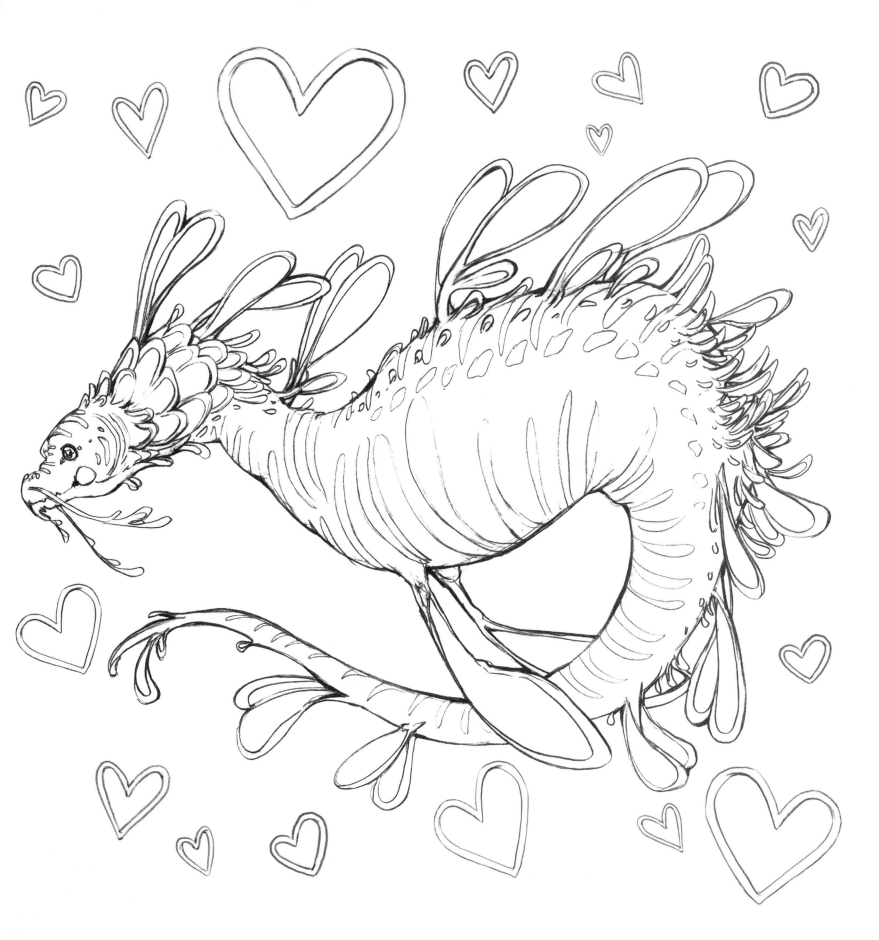

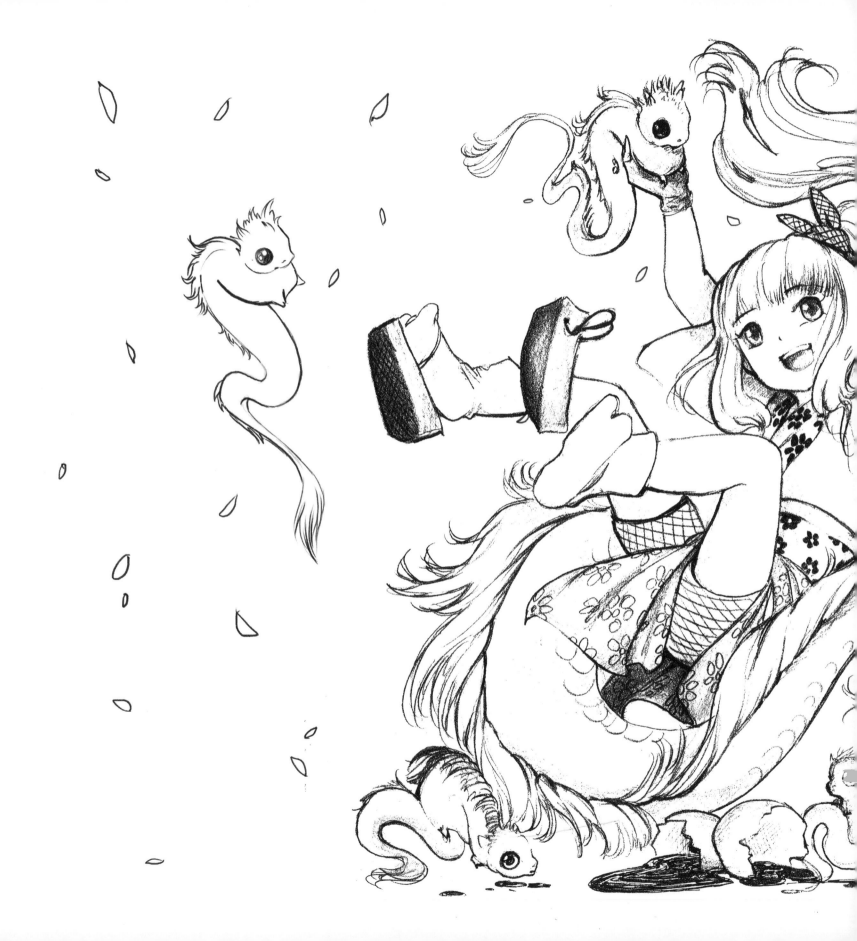

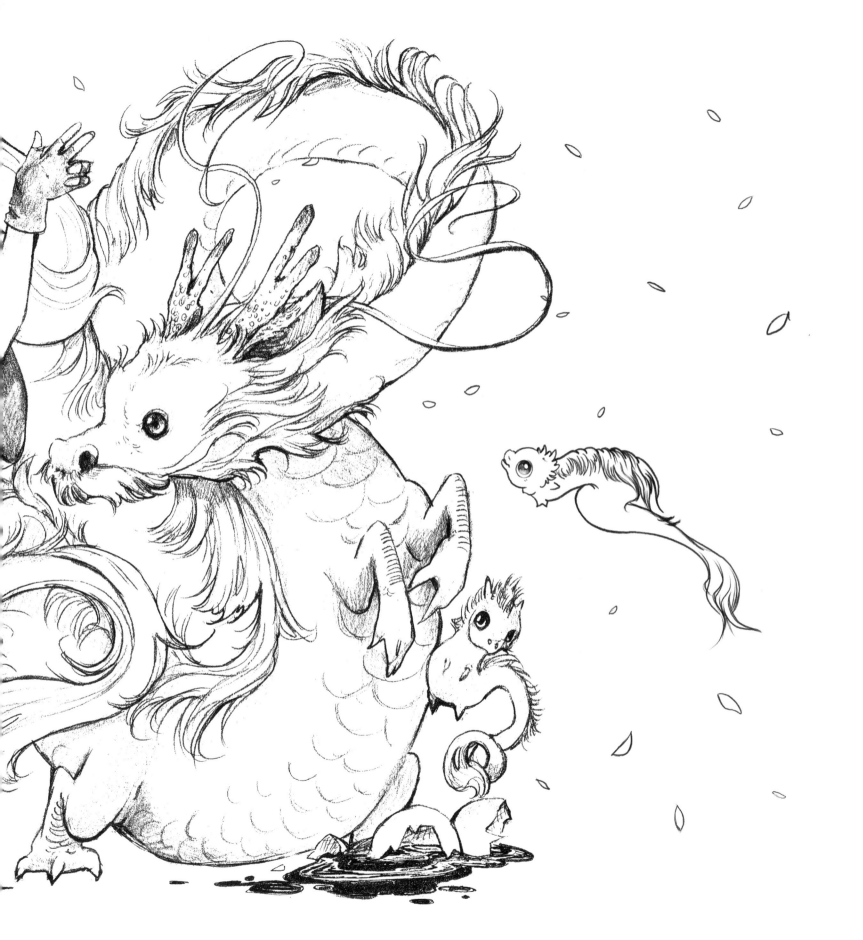

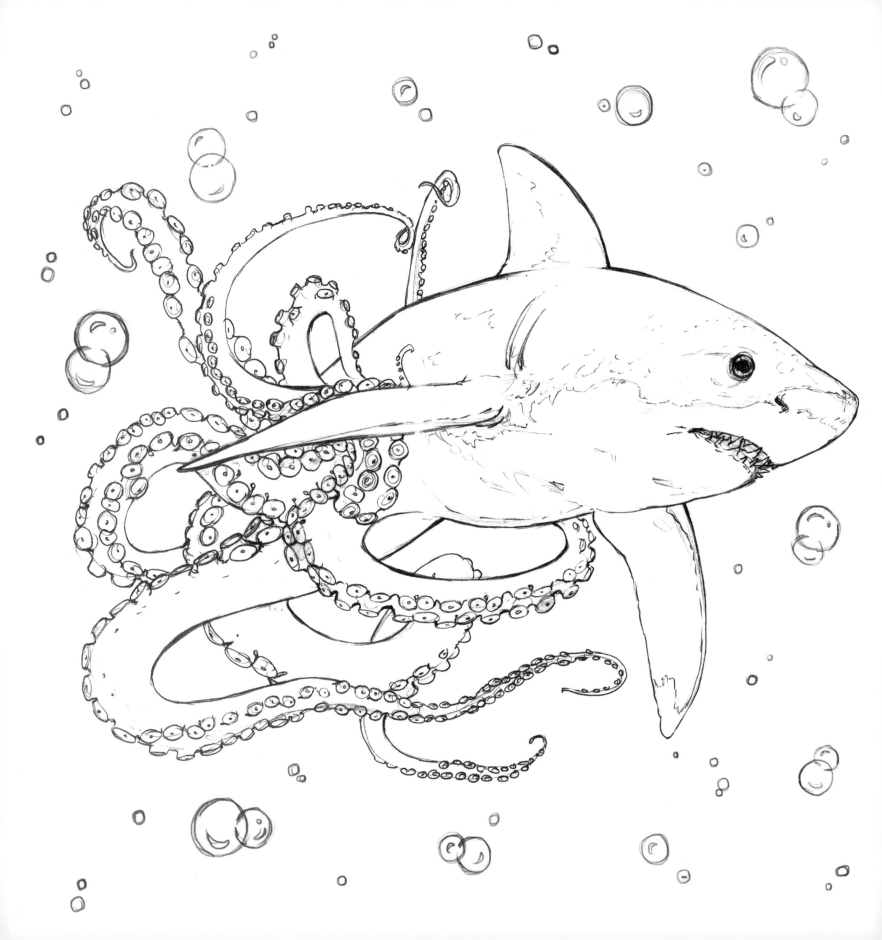

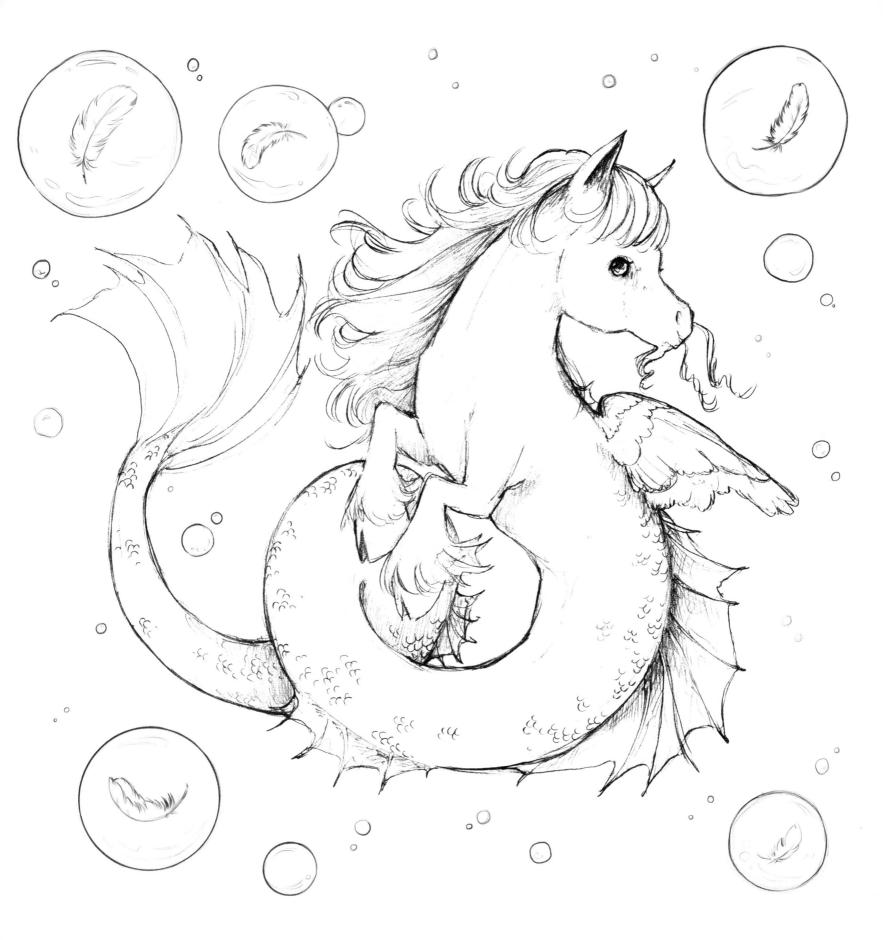

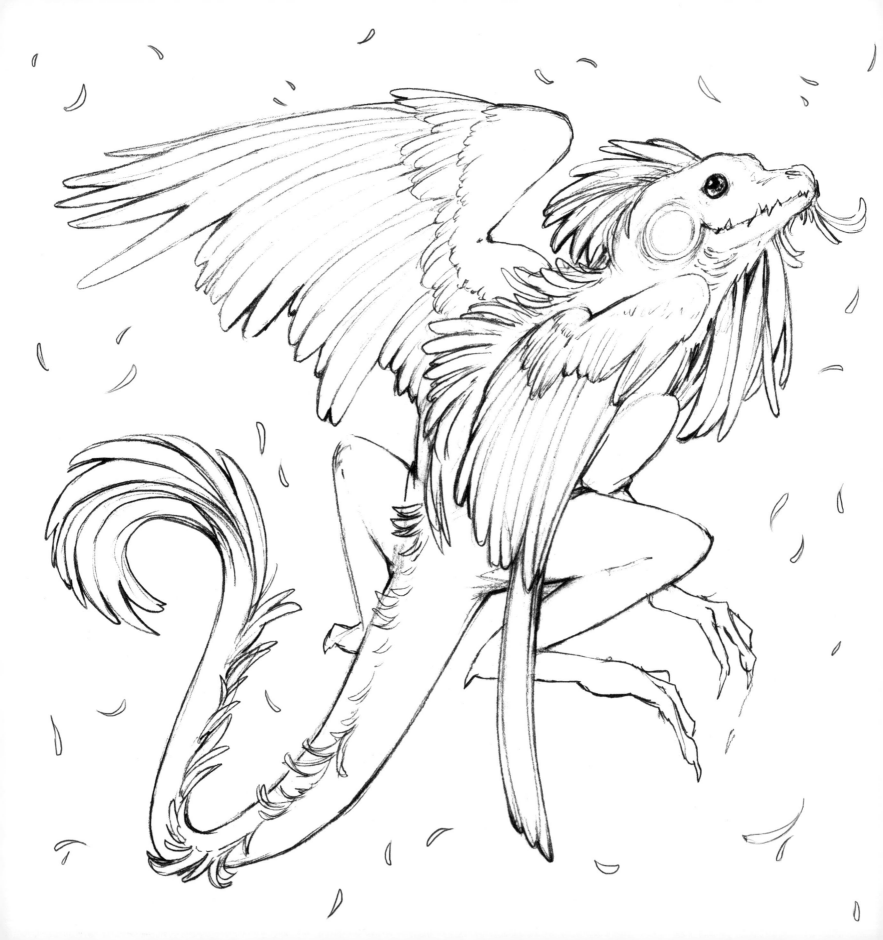

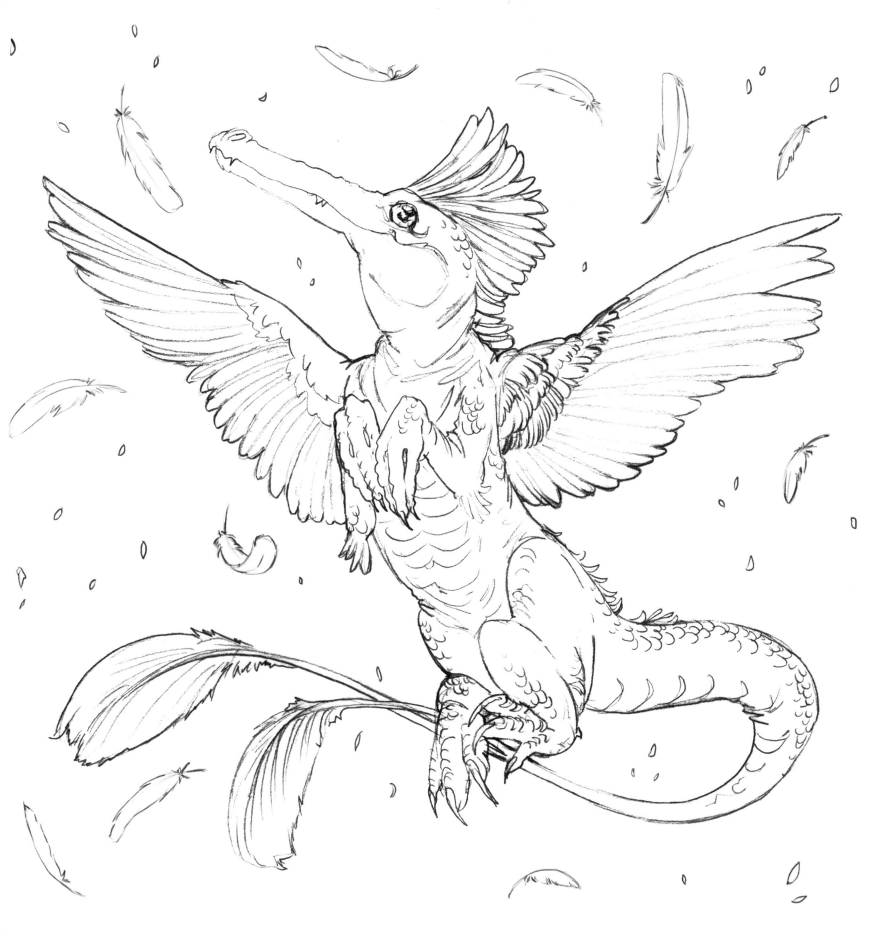

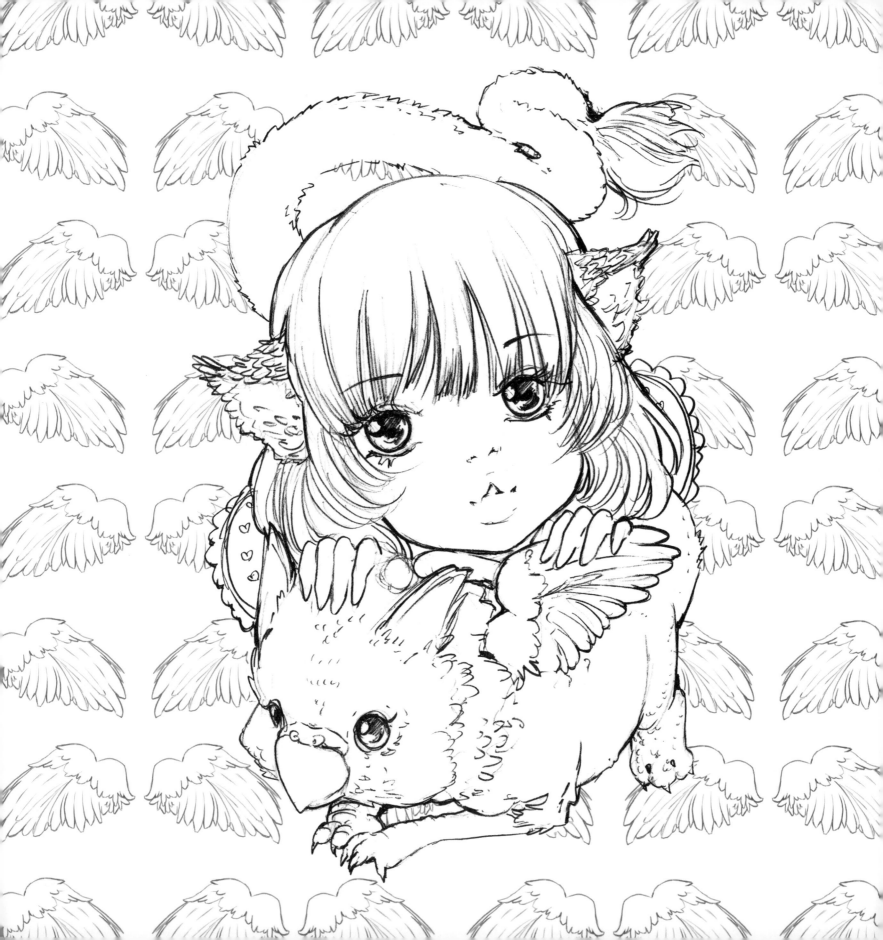

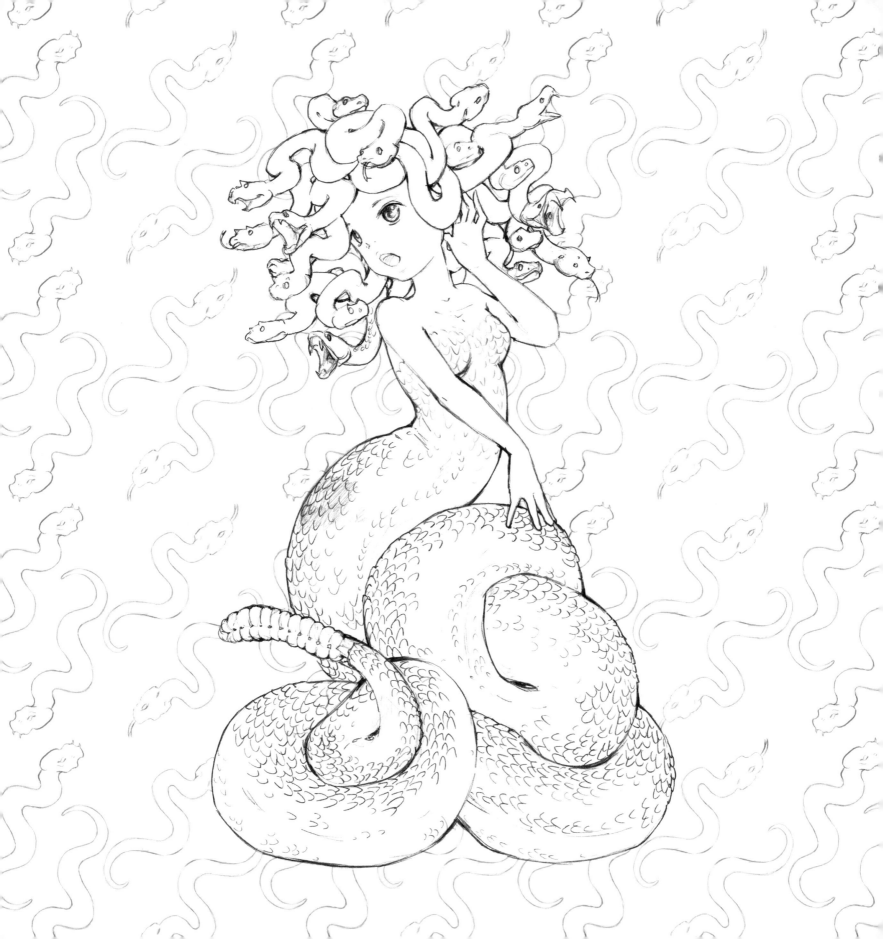

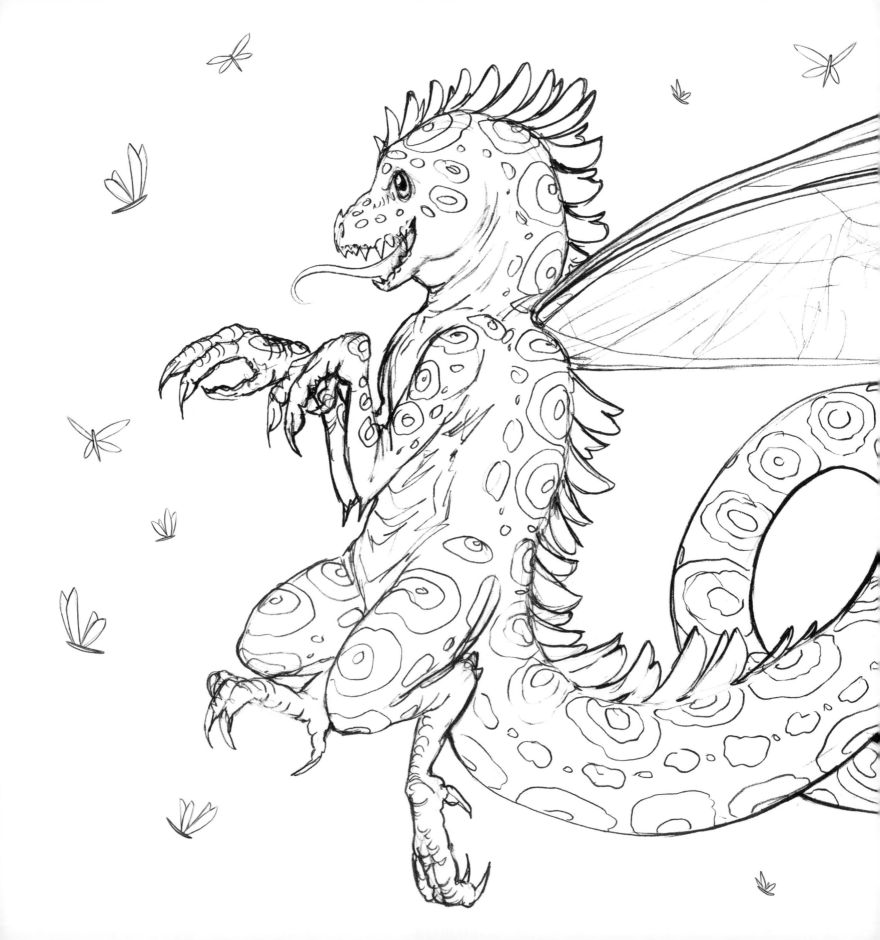

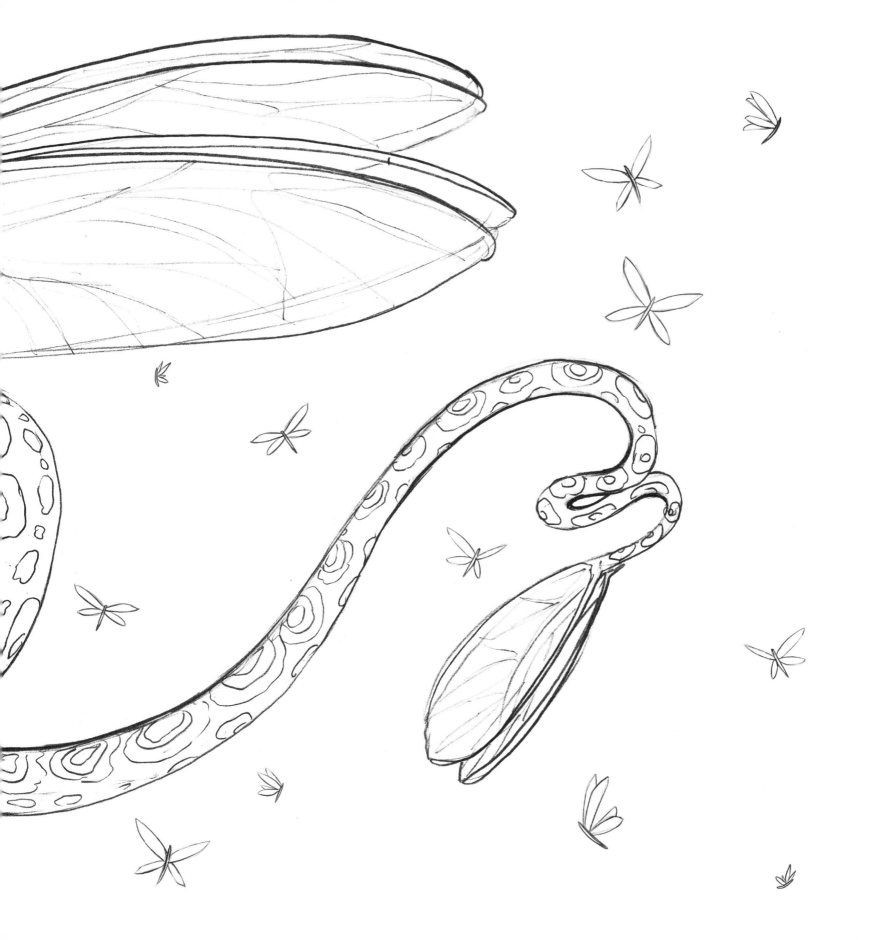

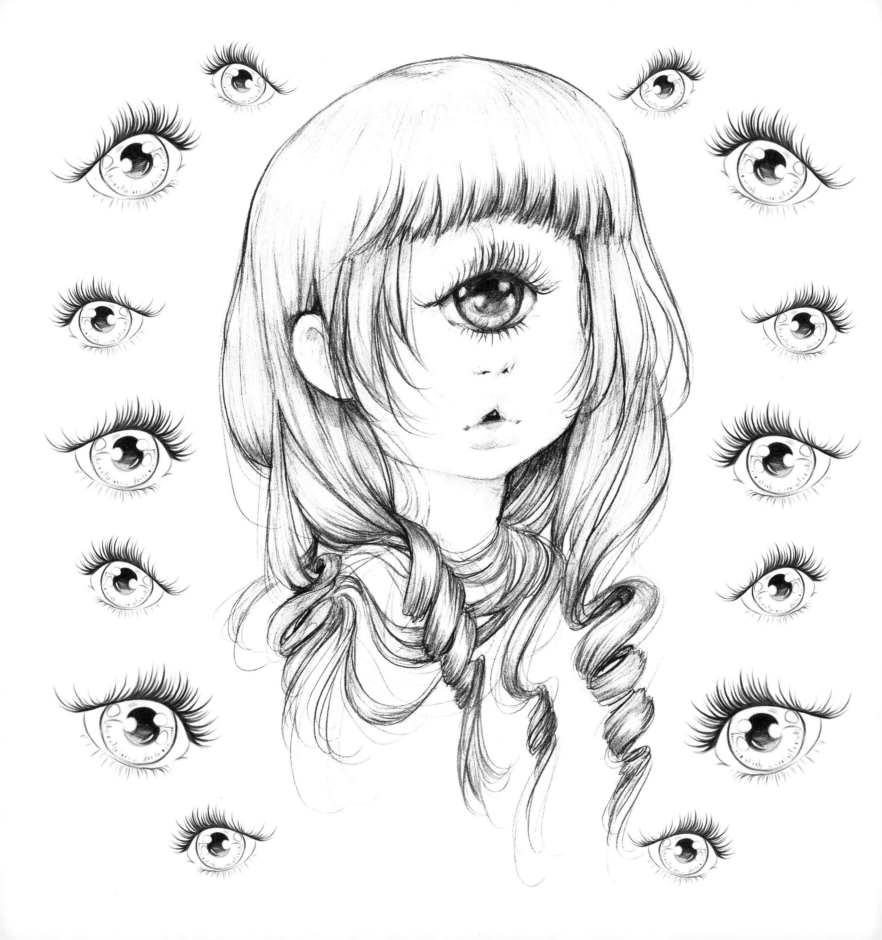

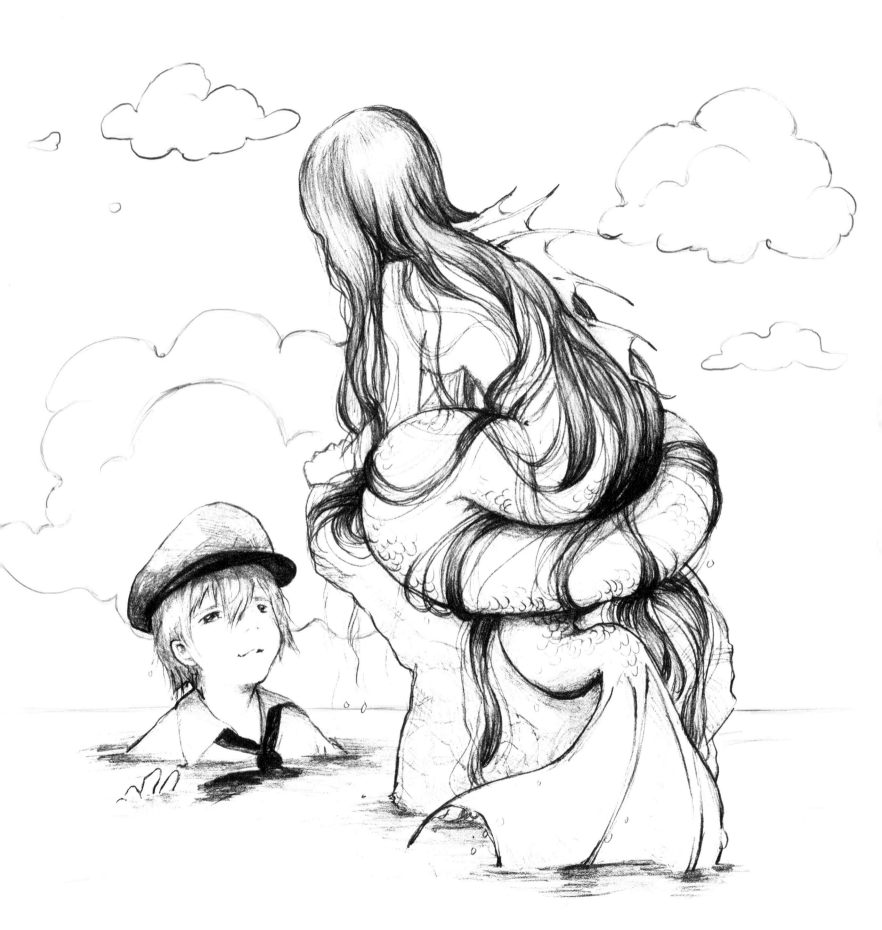

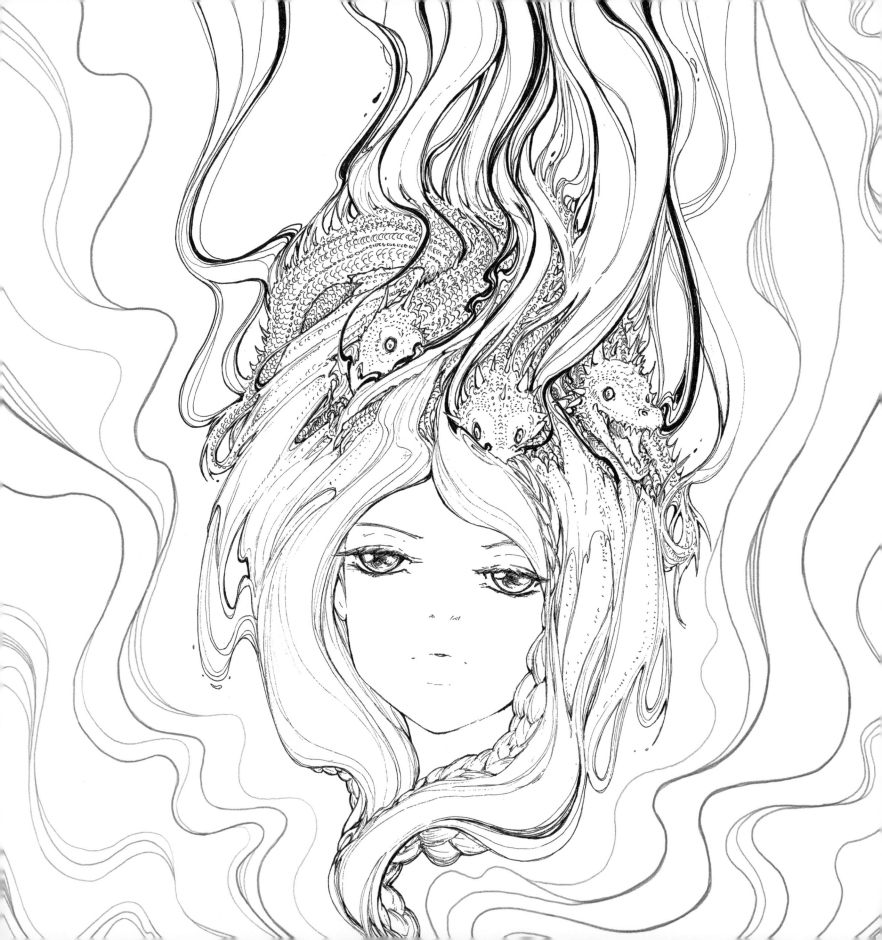

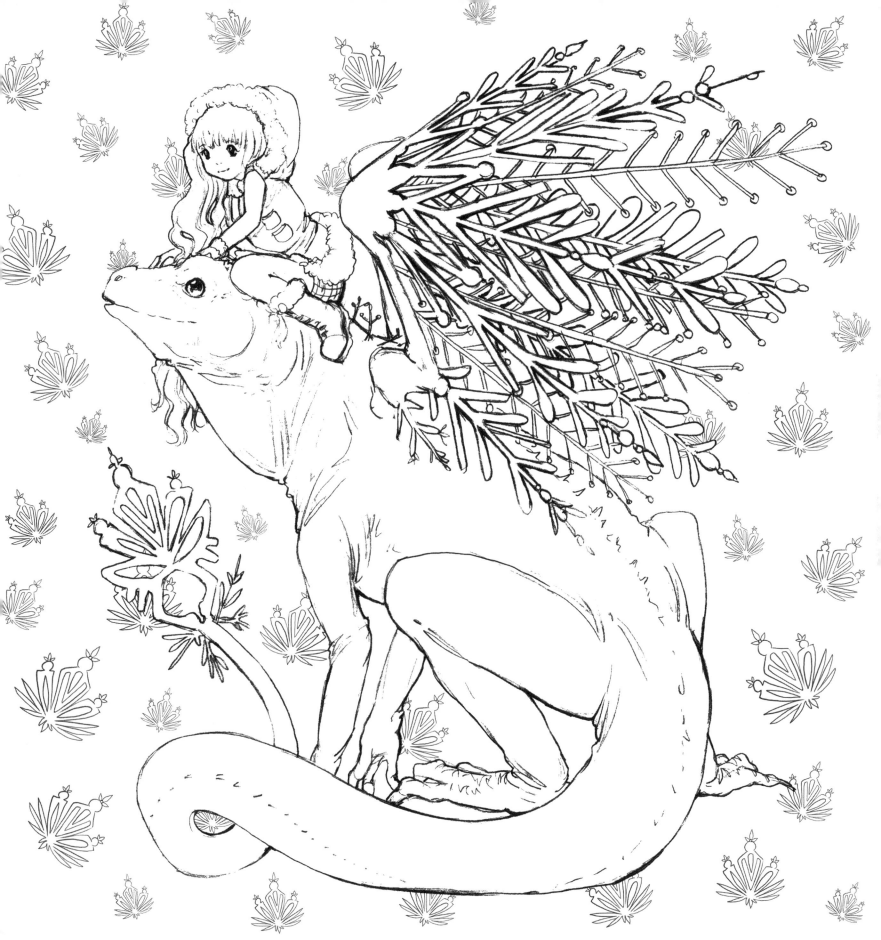

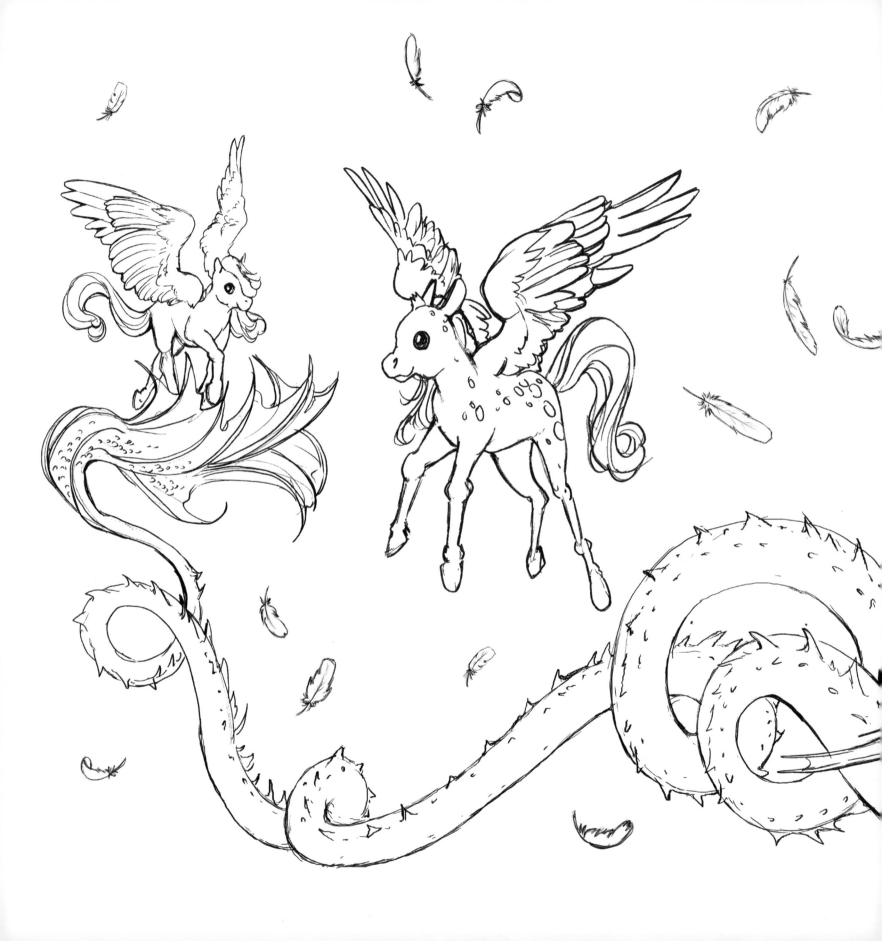

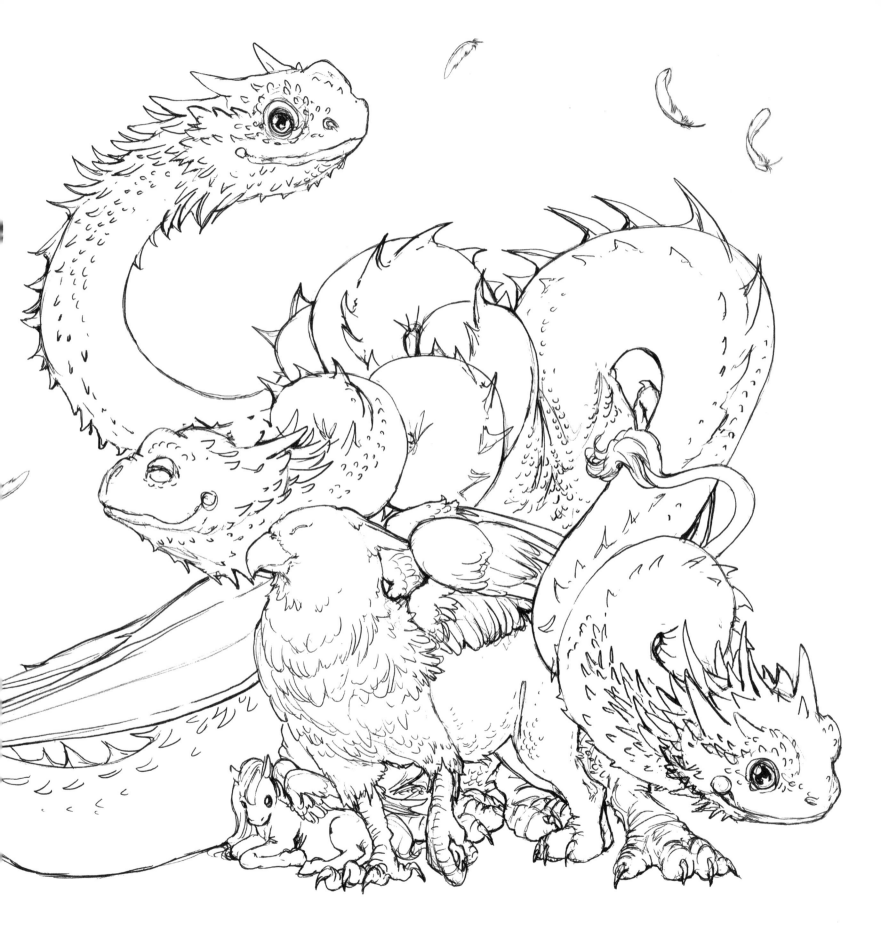

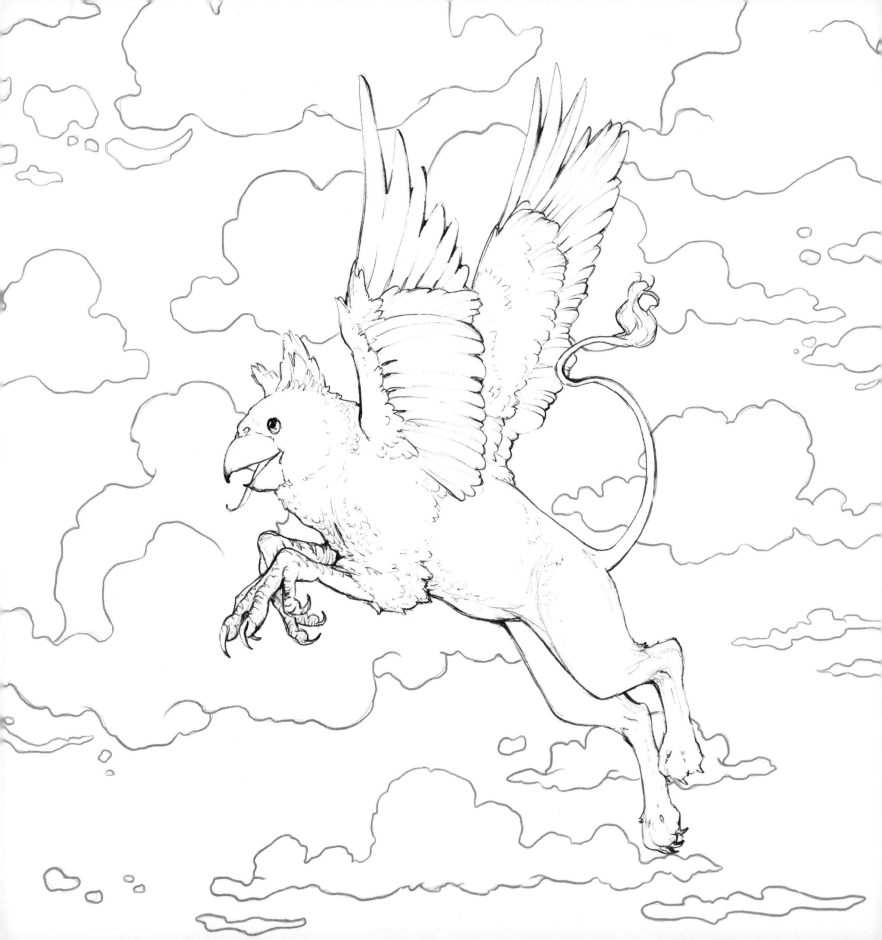

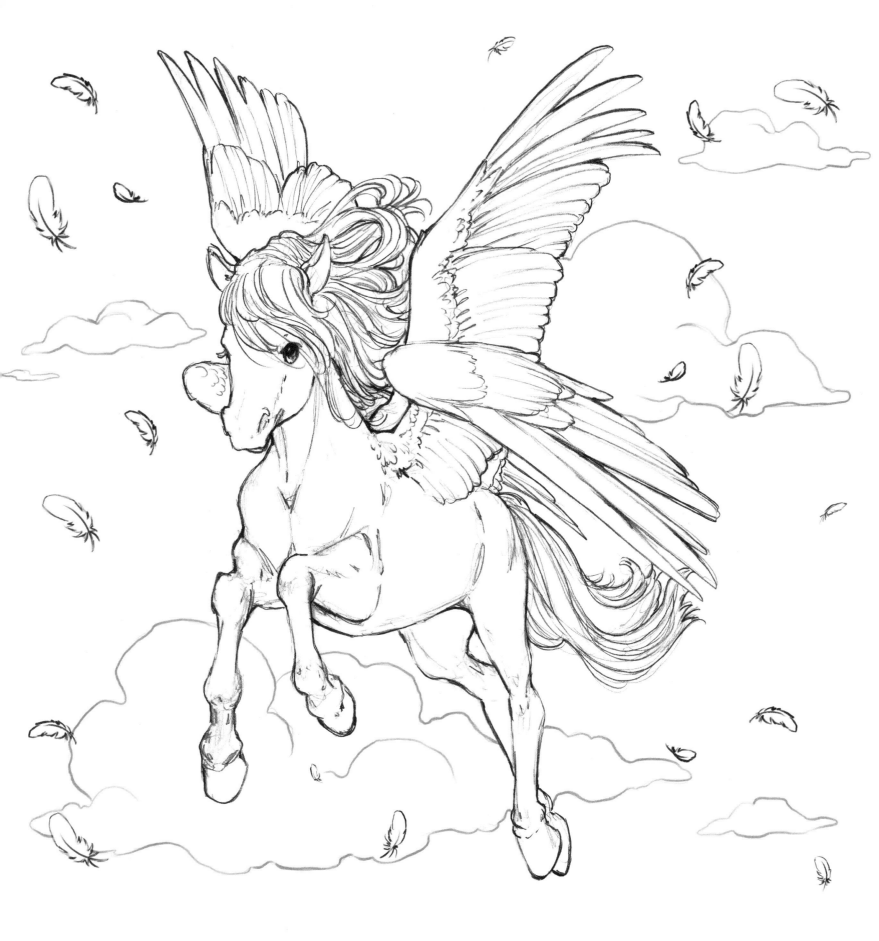

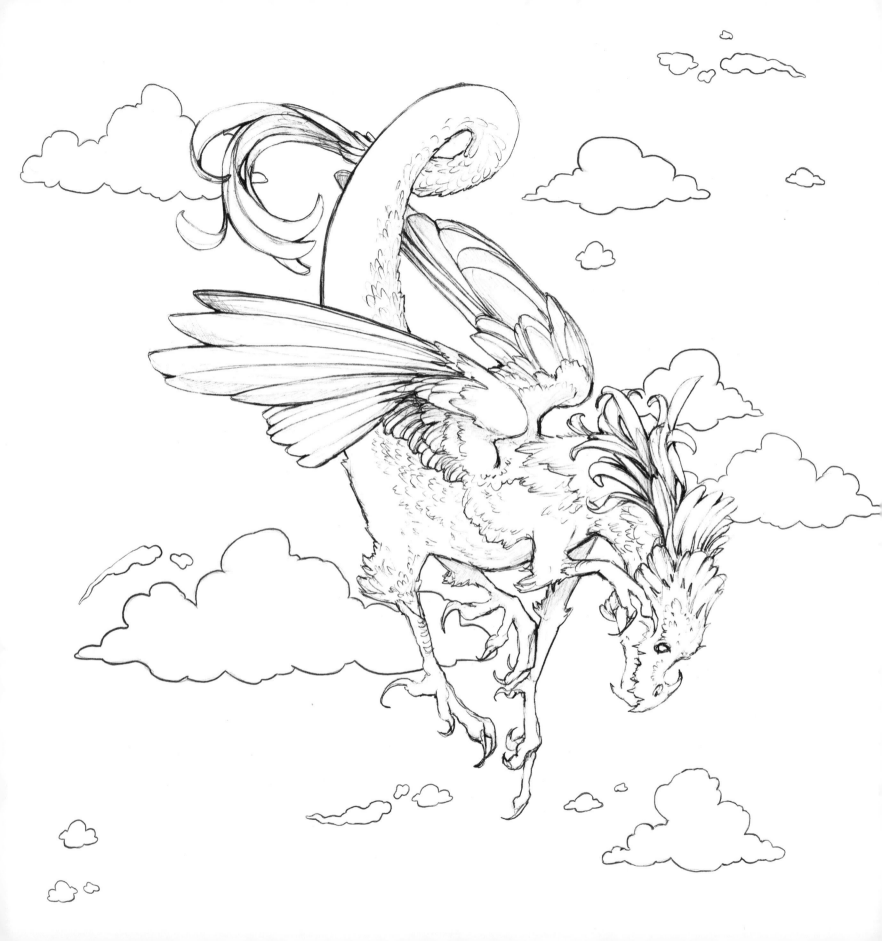

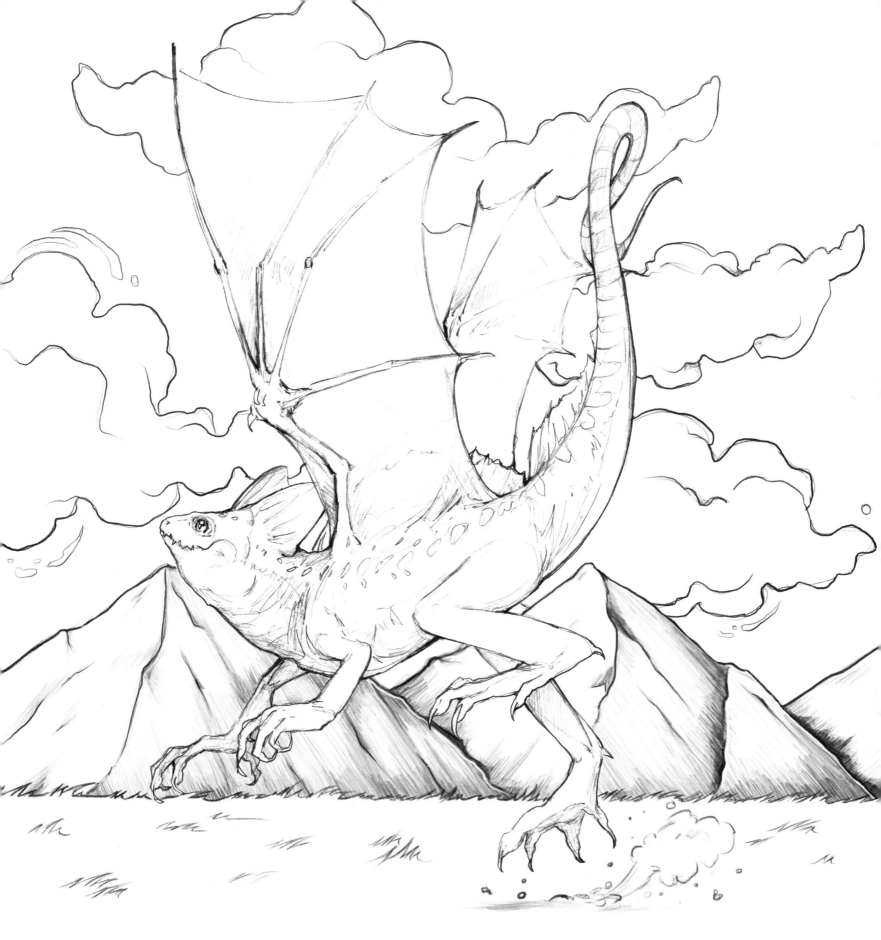

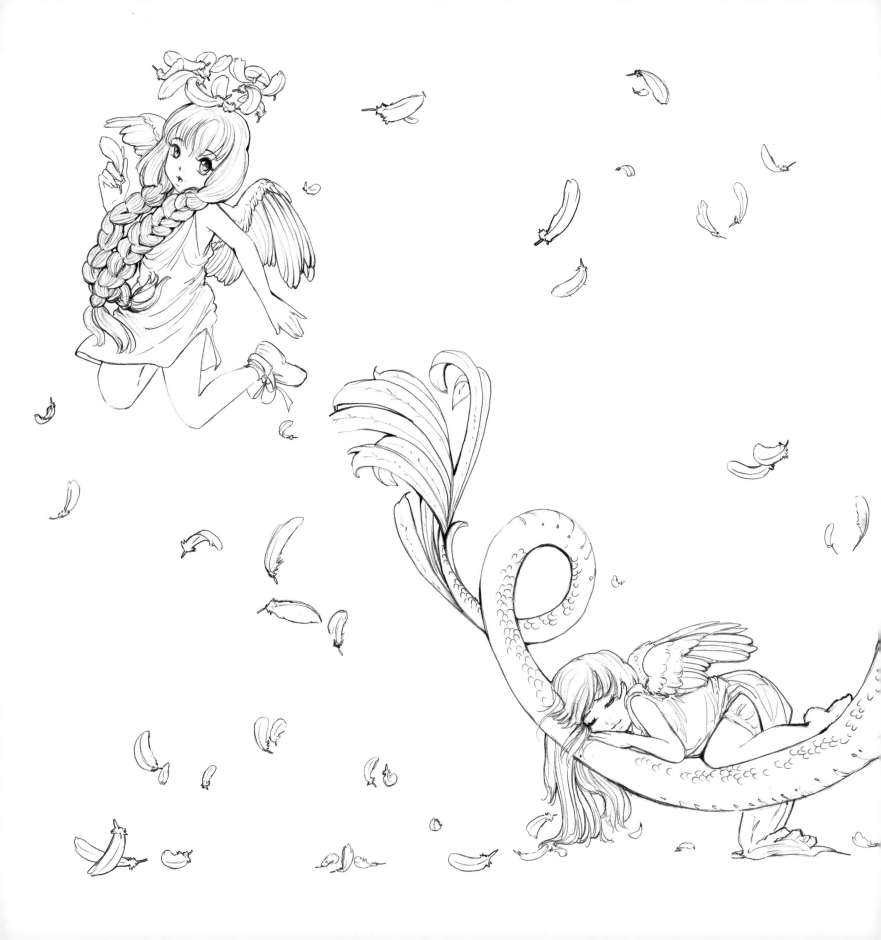

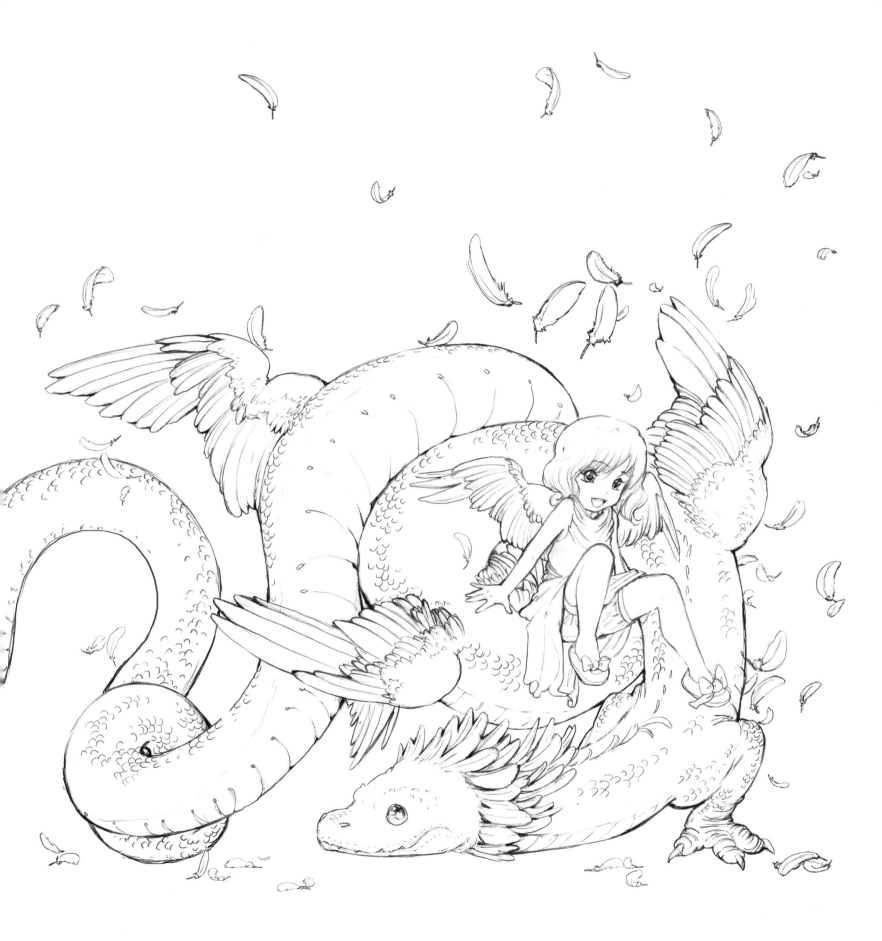

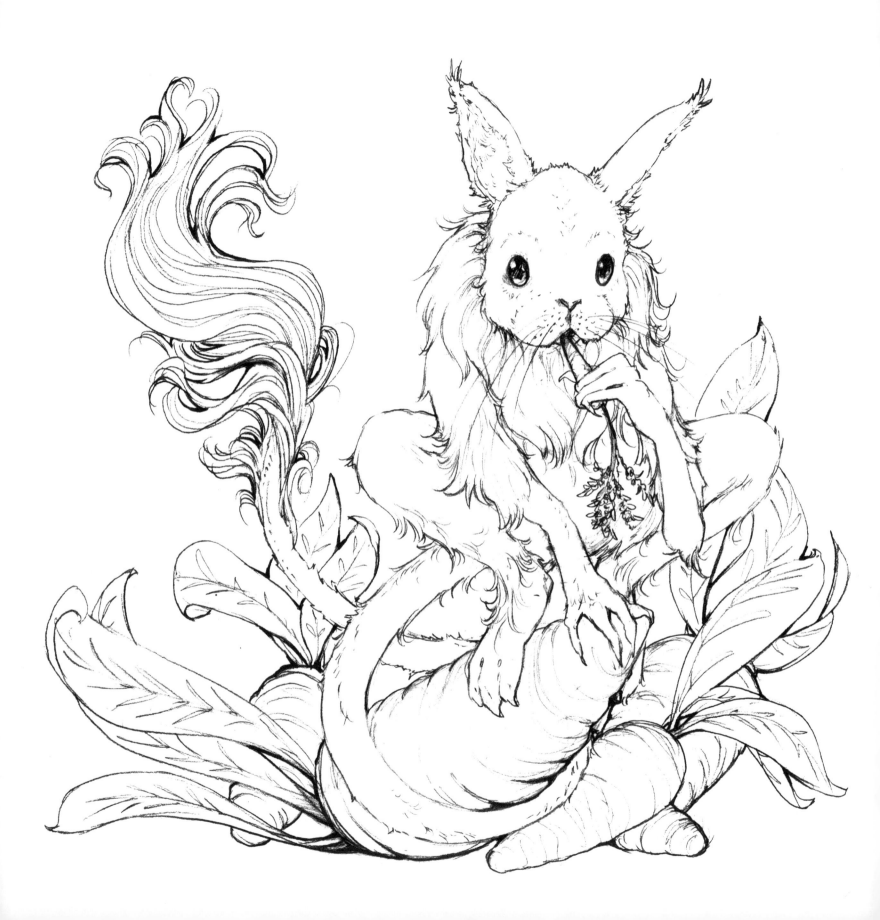

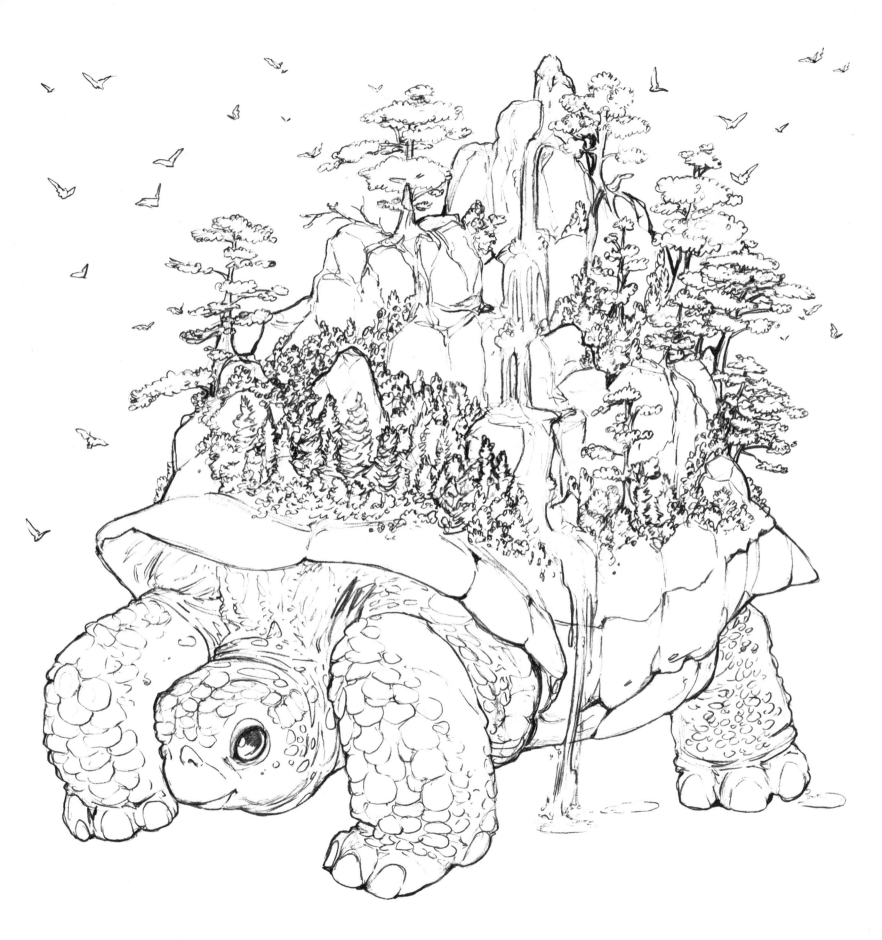

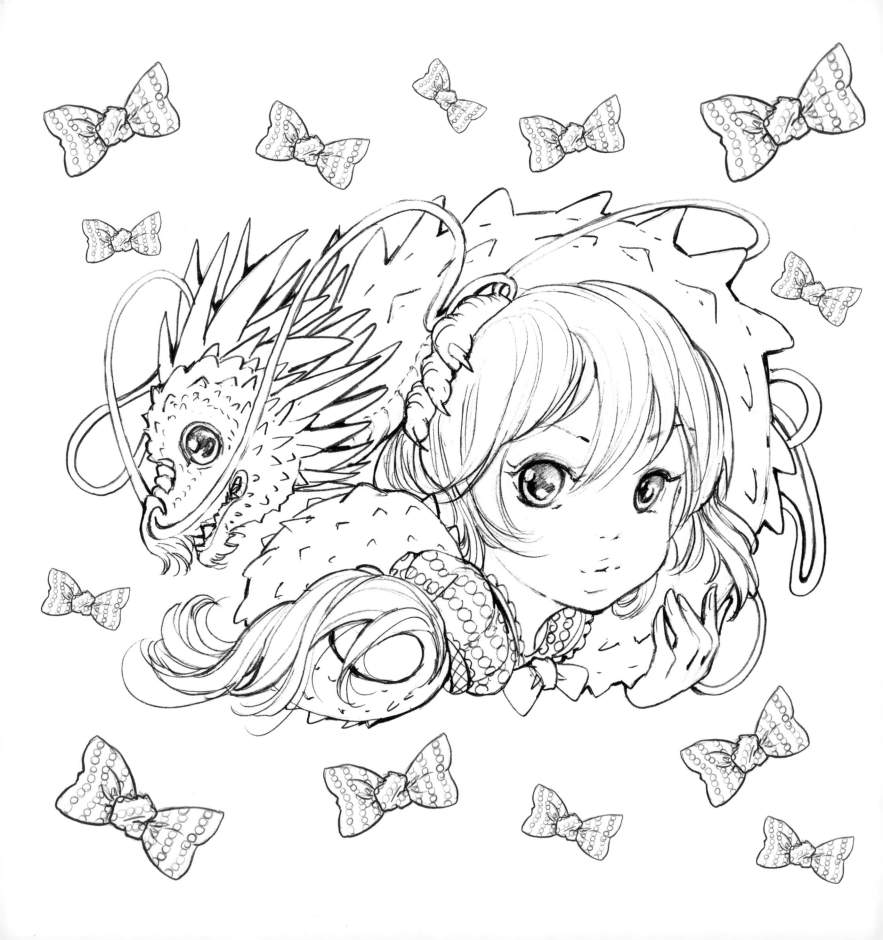

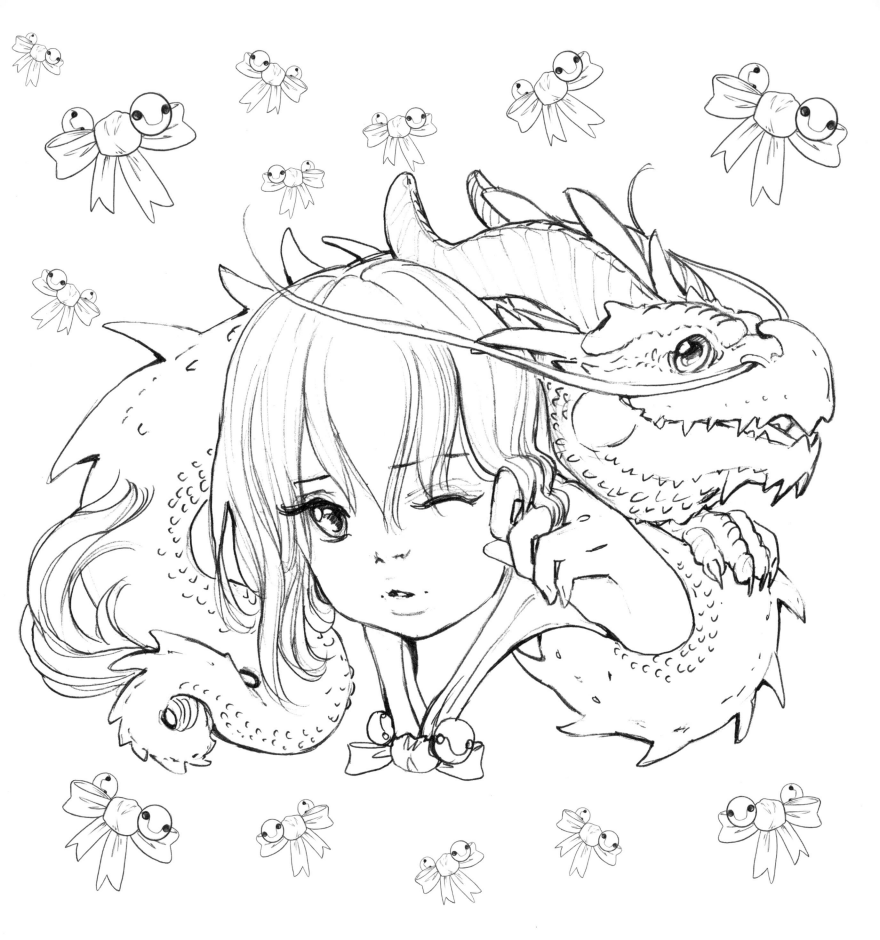

Copyright © 2022 by Camilla d'Errico.

All rights reserved.

Published in the United States by Watson-Guptill Publications, an imprint
of Random House, a division of Penguin Random House LLC, New York.
www.watsonguptill.com

WATSON-GUPTILL and the HORSE HEAD colophon are registered
trademarks of Penguin Random House LLC.

Trade Paperback ISBN: 978-1-9848-6086-6

Printed in China

Acquiring editor: Kaitlin Ketchum
Project editor: Want Chyi
Production editor: Doug Ogan
Designer: Lisa Schneller Bieser
Art director: Chloe Rawlins
Typeface: HDV Font's Brandon Text
 by Hannes von Döhren
Production manager: Dan Myers
Publicist: Lauren Kretzschmar
Marketer: Monica Stanton

*The author gratefully acknowledges
Savanna Reardon-Cannaday for her design
work and dedication to this project.*

10 9 8 7 6

First Edition

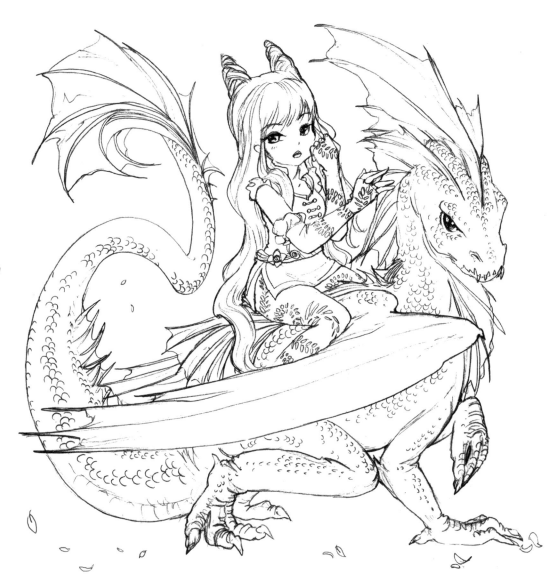